HOME
IMPROVEMENTS

ideas from an architect

Keith James Clarke

ISBN 9781527291607
Copy-editing by S. Norman
Photography, design and book production by S. B.
Printed in England by Swallowtail Print

Front cover photograph
Detail of author's bathroom ceiling, London.

All photographic images, drawing and sketches in this book have been produced for *HOME IMPROVEMENTS: ideas from an architect* devised and written by Keith James Clarke (Architect).

A copy of this book is available from the British Library.

First published in Great Britain in May 2021 by
 Oblique Angle Publishing
www.KeithJamesClarke.com

www.carbonbalancedpaper.com
CBP002269

Contents

' All the variety, all the charm, all the beauty of life is made up of light and shadow. '

TOLSTOY

FOREWORD

We have all moved into a newly purchased house or flat and wondered what we could do with it to make it "ours." Even the most beautifully decorated and designed spaces will need something personal. Whereas, at the other end of the spectrum, complete renovations can leave people daunted about where to start.

There are a lot of books, magazines and television shows that give advice and ideas, but it is difficult to wade through so many alternatives. That's why Keith Clarke's book is so interesting and inspiring. Keith has taken his years of experience as an architect, combined them with his exceptional skill of conveying complex ideas simply and effectively, and put them into this excellent book. His practical approach, wonderfully illustrated, shows what you can do, and how to do it. You can read it in one go or dip in and out, either way there is so much insight delivered in a way that makes you want to get up and start right away.

Reading this book will make you think again about that difficult room and how to finally get it right. It could inspire you to take on a new project, which might have seemed too much of a stretch before. Most of all, it will give you practical ideas of how to make the space you live in that much better.

I hope you enjoy reading it as much as I did.

Mark Malcomson CBE
Principal and Chief Executive of City Lit

The World Crisis of 2020-2021 will shape the lives of generations. So I made use of some spare time during the third national lockdown and compiled a to-do list. One item raised an important question. What was I to do with my portfolio of design projects? Thankfully most of them had been built, and I was halfway through a couple of new designs. My projects consist of A2 original drawings, notes and photographs – cherished possessions that are a record of my professional activities since the 1980s.

I separated out the multimillion-pound schemes for developers and a few competition entries and put them to one side. That left my designs for apartments and houses. I returned from a walk in a London park, knowing that I needed to write another book. It would utilise my work as an architect, university lecturer and enthusiastic builder and be a meditation on Home Improvement – from an architect's perspective. As I started this new venture, I became aware that I needed to address key questions. Broadly, are UK Home Improvements successful and do they offer value for money?

Architects, interior designers and structural engineers produce some fascinating work and use their vision, expertise and creativity. But for home owners seeking to deliver small scale Home Improvements, which is the focus of this book, the way forward is less clear. Projects come in various forms, including bathroom or kitchen refurbishment, extensions, garden terraces or merely the decoration of a single room. Often work goes ahead without an interior designer or architect – perhaps to avoid fees and because the home owner doesn't feel their project warrants specialist advice.

On numerous occasions when travelling by train, I have observed many refurbishments in the form of alterations to the backs of properties. For the most part, many of these Home Improvements are visually very disappointing, and I have also felt concerned over their choice of materials and long term durability. This outcome is not compatible with home owners' expectations, who demand quality at a reasonable cost. Talking of cost – there's another problem.

If you have a pair of builders (2021) working on your home for, say, two weeks, based on £180 per person per day, the labour cost alone will amount to £3,600. Add to this, say, £2,400 for materials, and the cost is approximately £6K. For this sum, you might have refurbished your existing bathroom plus new shelving for your second bedroom; but this is a modest return for your money. This is for an improvement to an existing space only, not a new floor area. What's more – you may be paying back

the loan for several years to come. Clearly, small-scale improvements for residential properties have issues to do with building quality and made worse by high procurement costs. What can be done?

Read this book. It's brimming with design ideas and has **Twelve Case Studies** that explore a series of design interventions with details of how to get things built and a **Skills Workshop** that will make you feel more confident of getting started. And at the back of this book is an **Action Plan** that will get you thinking about your future projects – all supported by essential material in the form of drawings and photographs.

You will see that the case studies start with simple interventions – a flower box, internal door and a storage cupboard – and progress to more ambitious Home Improvements in the form of a walk-in wardrobe, single storey extension, loft conversion and one bedroom flat. And as you make this journey, you will use your newly acquired skills to get your ideas down on paper. This will help define a new way of attaining your Home Improvements with the opportunity of carrying out simple tasks like tiling and decorations after your builder has left. And also contained in these pages are material that will also benefit those employing a professionally trained expert for more complex projects. In this case, you will

be free to have a more informed discussion with your architect or interior designer about *your* project as it evolves over time.

As a tutor for some 35 years teaching across all age groups and levels in architecture and interior design, I have discovered that when committed students become familiar with basic skills, it's not long before they start thinking creatively. And with current interest rates so low, now is the time to make use of your skills and knowledge. The financial difference between you getting involved and leaving it all to your builder saves about 30%. This may be the difference between your project going ahead or hitting the buffers.

This book will bring order and understanding to the home owner approaching this subject for the first time. You will discover it is not merely about DIY. Instead, it offers a window into the joy and wonder of interior and architectural design and how to use it to improve the quality of your home. I hope these case studies expand your knowledge, assist you in realising your ambitions and mean as much to you as they do to me. So hop on board, and let's get started!

INTRODUCTION

Buying a property for the first time is exciting. I recall exchanging contracts then finding myself seated on a train from Cambridge to London. I couldn't stop myself saying to the gentleman opposite, 'do you know – I bought a house today?' He didn't look impressed. So why bother stretching your financial resources to buy and improve your home? The answer is simple – it's extremely rewarding. An inviting space, the play of light and shade and beautiful furniture are life-enhancing.

But there's a potential problem. By the time you have arranged the purchase and paid legal fees and removal costs, you may have precious little money to make the property feel your own. I have a suggestion. Colour is a very cheap way of addressing this situation – it doesn't cost any more than painting the walls white and, if you can improve the floor finish too, it will look even better. And this is why in **Case Study 12**, I look at how colour can be used for a one bedroom flat. And because external seating, bathrooms and kitchens lead the field for the most popular Home Improvements, I look at these in **Case Studies 5, 7, and 10**. From the design of a window box, through to a ground floor extension, from the removal of an entire roof – and its replacement – to the design of a whole apartment: you will be guided throughout the development process. And each project will be evaluated – what works, what doesn't.

Who is this book for?

This book has been written for members of the general public seeking to improve their home and want to be inspired by new ideas. It is ideal for those interested in this subject, including those willing to get involved by carrying out simple building tasks. You may have already appointed an architect or interior designer but seek a broader understanding. Here, this material will make you feel you can engage more fully in the process, secure in your ability to ask a telling question, which often has the effect of sharpening up the quality of your builder's work. And that is why this book includes approximately 65 drawings and 100 photographs to help deepen your understanding of this fascinating subject.

It has also been written to address the concerns of designers (in the broadest sense), builders, and students of architecture, interior and 3D design. And here, it is tempting to think that those in the Building Industry will find **Case Study 4** onwards of particular interest. But bear in mind that all the studies in this book have a design element and place visual quality high on the list of priorities.

How to use this book

You may choose to read the case studies out of order to address individual concerns. This is fine but remember to look at the **Action Plan,** which summarises key issues and provides a checklist for your use.

Summary of Case Studies 1 to 12

CS1 Would you like to augment the view from your lounge? Here I explore an idea for the enhancement of **window cills** that also makes a positive contribution to the environment.

CS2 This case study looks at an attractive alternative to standard **internal doors.**

CS3 And here I look at a purpose-made **cupboard** that addresses user need and provides an attractive alternative to flat-pack furniture.

CS4 This case study deals with the aftermath of severe water damage and how a **lounge** was brought back to life.

CS5 And this investigation looks at how to create a useful **external space** for relaxation and enjoyment.

CS6 Short of space for hanging clothes? I look at how to create a **walk-in wardrobe** that also increases general storage capacity and celebrates the character of an existing property.

CS7 In this study, a non-load-bearing wall to an existing **bathroom** is demolished, and another built approximately 1.1m further back with the layout shaped by the wall tile dimension and split level design.

CS8 Case study 8 requires the existing roof to be removed and the conversion of a **loft** with opportunities for natural light and excellent views.

CS9 And in this study, a 1960s conservatory is demolished and replaced by a new **single storey extension** with strong environmental and architectural credentials.

CS10 Are you interested in open plan arrangements? Case study 10 takes an existing space and explores options for a **lounge, dining and kitchen.**

CS11 The design of this **studio** in Cambridge was created in response to my client's need for minimal change to his much-loved building.

CS12 Here, a beautiful Victorian building in west London is converted into a small but delightful **one bedroom flat** with colour playing a key role in the design.

I suggest you look at the case studies and see how you feel about the character of each one. Pick up ideas and use those that capture your imagination and put to one side others that aren't relevant to you. And look upon each case study as a way of building up your knowledge. You never know when this may come in useful. I only appreciated the full significance of my tutors' advice years after their message was delivered!

——

' Interior and architectural design must recognise the aspirations of people. At the same time, space and light are fundamental: they shape our lives and lift our souls. '

Keith James Clarke

——

So you are looking to improve your home. Are there any principles – ways of working – that will assist you?

User Need

It's a good idea to type up your requirements for your Home Improvement. They may change over time, so be prepared to update your copy. Whilst defining user need can be challenging, it is an essential part of the process and will determine the success of your project. For commercial projects, design teams do not always accurately record their clients' requirements. You might reflect on why this is so? Sometimes, the people who later use the building are not even consulted at the briefing stage. That will not happen with your projects, so think long and hard about your user needs in detail, and work towards achieving them.

Design

You will also need to be determined in developing your design ideas, revisiting them to make improvements and using techniques outlined in the **Skills Workshop** section of this book. Is design easy? No – but it is fascinating. And don't be afraid of making mistakes. Recognise that, particularly during the early stages, you may be unclear where your design is going. Be prepared to play. I find that I sometimes come up with what might appear to be absurd ideas. But, with

modification and reflection, they can become worthy of serious consideration and implementation.

You also need to pay attention to the tiny details of your Home Improvement. The design of each component is crucial. For example, the choice of a storage cupboard, its door handle, the profile of the adjacent skirting – all contribute to the quality of the visual environment. And it's the integration and interrelationship of all these elements that count. Sound is important too. For example, your feet treading on gravel as you approach the threshold of your home becomes part of your visual and aural experience.

Glazed Areas

Natural light from glass in the roof or wall will increase the quality of your interior. I was reminded of this recently. Whilst standing in a supermarket queue, I noticed there was a delay at the checkout. I turned to the sales assistant and asked, 'what's it like working in this environment?' She replied, 'the trouble is – I never know what's happening outside'. We were standing in a noisy warehouse, there were no windows, and the lighting was poor. Try to get natural light into your home. Remember that during overcast days, light from windows in the wall will not project far into a space, perhaps only a few metres.

Consider, if possible, getting some roof glazing furthest from the windows. Believe me – it will pay dividends.

Electric Lighting

There are three basic methods of lighting a space: General, Task and Accent. General lighting provides a comfortable level of illumination, typically from a ceiling light. Task illumination, as the name implies, illuminates specific areas for, say, reading or studying at a table. An example of this would be a table or floor light that throws light directly onto the page. And Accent lighting creates a focal point - patterns of light and shade that emphasise the surface of a wall and atmosphere of a space. A well-designed lighting system will significantly impact how you feel, provide a suitable welcome, and satisfy your needs for work or relaxation.

Space

I recall visiting an apartment in the Barbican, London. I walked into the reception and was confronted with a balcony overlooking the dining room. Although the reception consisted of a single height space, the dining room was blessed with a double-height space – some 5 metres tall. This surprising and dramatic feature was responsible for a lot of interest from tenants and purchasers and contributed to its visual quality.

When designing a space, there are plenty of issues to think about. For example, there may be benefits in removing the ceiling to expose a sloping roof above. It may be possible to raise or lower the floor. This may develop the quality of the space and provide a useful place for mechanical and electrical services. And it may be desirable to create a sense of transparency by providing a view from one space into another. If you want the spaces to flow together, you might use an identical wall, ceiling and floor finishes throughout. But if you want a different feel to each space, you may choose to specify contrasting finishes.

Circulation space is essential too. What do I mean by this? Within the context of your home, circulation space consists of space used for the movement of people, such as entrances, corridors, stairs, landings and so on. So try to ensure that the circulation space in your home provides an obvious and unobstructed route. You will have witnessed examples where this issue has not been handled well. For example, returning to the Barbican, I recall observing visitors as they entered another part of the building – the Concert Hall Entrance. They simply didn't know where to go! Yellow lines were painted on the floor with support staff in public areas to help, but this should not be necessary. Remember that people occupy space, so be careful to provide sufficient room for people to move around freely without bumping into each other or items of furniture.

Financial Considerations

It would be inappropriate for me to release details of costs for my projects – apart from anything else, they become unreliable over time. Also, these depend significantly on several factors. For example, I have produced kitchens for a few thousand pounds. On the other hand, it is not unknown for some home owners to spend more than 50K! It's all to do with the quality of the specification, complexity of the build and other factors involving the project's character.

One way to get helpful cost information for your project is to put your requirements down on paper and get two or three builders to quote. (Details of this drawing technique will be given next.) The quotes will be free and provide you with accurate information, and you can then modify your proposals accordingly. Time spent looking online, leafing through magazines and visiting Builders' Merchants, including Architectural Salvage Centres, will also pay dividends. Some salvage centres buy and sell anything of interest – so you never know what you might find. There are good bargains to be had if you put in the legwork.

Interpersonal Skills

Finally, don't underestimate the importance of relationships with others. Before writing this material, I produced a book, DVD and CD that looked at the composer, Gustav Mahler, and the places that inspired him and his music. I attended a film making course – and got my tutor to help me edit the DVD, a sound recording tutor to edit the sound and a historian friend to edit the text. These contributions were hugely beneficial. Developing positive relationships with colleagues is vital. And be prepared to learn from others – particularly those who have worked in the Building Industry for many years. If you approach it right, many will be willing to give you the benefit of their experience. You will save money too.

But take note. I designed my kitchen worktops using stainless steel. It has many advantages. It's hard-wearing, heat resistant, and the long panels can be welded on-site for easy installation. (This avoids, for example, bread crumbs getting stuck in the joints between worktops.) I was informed by a specialist contractor that I would not be able to see the welded joint. However, it transpired that, even after sanding, the weld was visible. I have encountered other occasions when information from so-called experts was inaccurate.

SKILLS WORKSHOP

Reading a drawing is a valuable skill that you can use to develop your design. It will also help you understand the drawings included in this book. Generally, I have produced my drawings at a scale of 1:50. This means that they do not represent the true size – instead, they have been miniaturised, i.e., drawn at 1/50 of their actual size. I shall explore how to produce a simple scaled drawing later in this section.

To get to grips with two key drawings, a plan and section, I have produced a 3D sketch drawing of a summer house. It has two windows, a door and a pitched roof. Inside is a sofa and coffee table. You will notice the joints between the timber floorboards. You can see the furniture on the plan and section drawing, plus a glimpse of it through the window of my 3D sketch. I have introduced a saw cut through the summer house. It is making a *horizontal* cut, approximately 900mm above the internal floor level. **1** This means that the saw is cutting through the door, windows and wall.

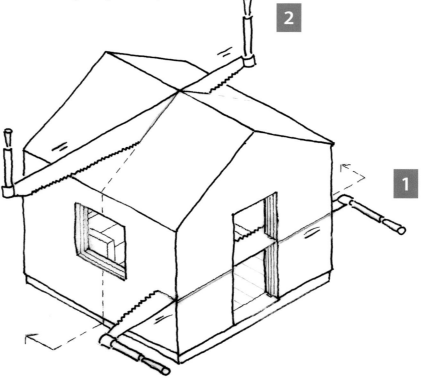

Sketch of Summer House

On my plan drawing, you can spot the external walls, door and windows. Because the plan is drawn looking downwards, you can also see the sofa, coffee table and floorboards. American architect Frank Lloyd Wright set great store by the value of a floor plan. It does indicate the general arrangement of a building – but it does not tell the whole story. Clearly, a downward-looking view is beneficial, but it does not describe the volume of the space. Neither does it provide information about the appearance of the walls. For example, is there a picture rail, are there wall lights and does the wall surface have a colour?

To address these questions, I need to produce another drawing. Go back to my summer house sketch, which shows another saw cut – this time *vertically* through the roof. **2** The saw cuts through the roof, window and wall on one side and a wall on the other. The saw continues to cut below the ground level, including the floor and foundations. As you can see from my section drawing, again originally drawn at 1:50, it contains a lot of useful information. You can see the walls, window, roof and floor slab thickness. You can also see a front view of the sofa, coffee table and window, including the top of the skirting board fixed to the back wall.

Note – the exact location of the vertical cut needs to be marked on the plan. You can see I have marked it as Section AA. This is because the arrangement differs depending on where the cut is made. You can draw as many sections as you wish. I tend to over-draw my projects, but I think that is a good tactic – it provides me with a deeper understanding of my design. (The annotation of either AA, BB or XX is of no consequence, what matters is that the mark on the plan matches that which is on the section.)

So plans have a *horizontal* cut and look down. Sections have a *vertical* cut and look sideways. In both cases, I have a simple message: draw what you see.

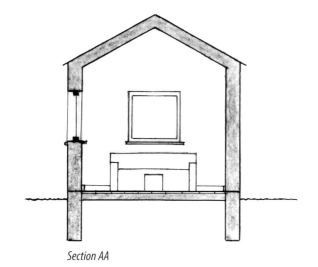

Section AA

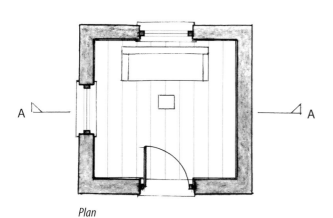

Plan

I can't overstate the part played by plans and sections. Architects, interior designers, 2D and 3D designers use them to look critically at their work – including the aesthetic merits of their proposal. And this graphical technique is crucial to the development of a design and forms the basis of the cost to carry out the work. From my experience, many disputes within the Building Industry come about because the builder never had a clear understanding of what they were supposed to produce and to what standard. Drawings are the best method we have to do this. But I have found that clients and builders feel unsure about reading drawings. This is not surprising; like most things in life, it does take time to get the hang of them.

Sometimes I draw a wall elevation. It is a 2D drawing that shows a flat surface and does not include a cut through the walls and roof – *as in the case of a section*. It's an excellent way of seeing what a surface will look like.

Clients are more receptive to isometric drawings. In this example, I have cut away the nearside wall to see part of the interior. You will notice that while most lines slope at 30 degrees – vertical lines remain vertical.

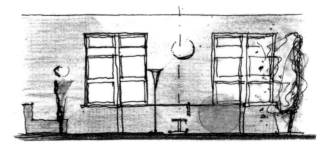

Sketch Elevation

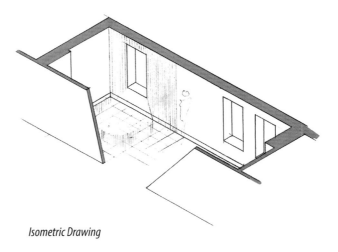

Isometric Drawing

I'm a big fan of simple 3D card models. Nothing elaborate is necessary – a rough card model is fine. I sometimes shine a light on the model and photograph it to give an idea of what the design looks like. And here, there is no need to invest time and money in Computer-Aided Design software. I recall working with a client to design her loft conversion. When I showed her the plans and sections, she said nothing. I then showed her the 3D model, and she did not hold back in registering her approval. The project got the green light on the strength of the model.

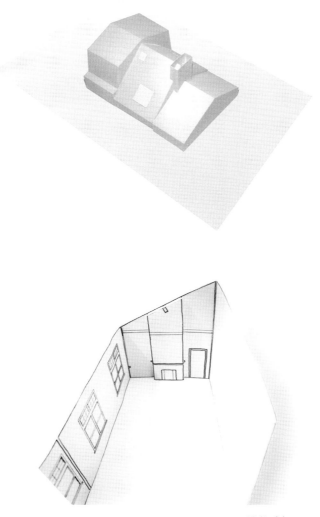

3D Models

I recommend you work towards using plans, sections, elevations, isometrics and simple 3D models to develop your ideas. It allows you to improve your proposals. Indeed, design students would not even be considered for a job in their field without being able to use CAD software. Its use has made a massive impact on presentation and visualisation. But there is no need to buy and learn a 2D or 3D software package at this stage. For the time being, look upon drawings and models as a helpful design tool. It can be inspiring to develop a design using a variety of graphic and modelling techniques. They help you understand the implications of your design.

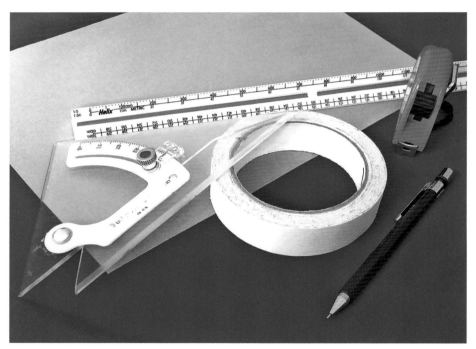

You may want to invest in some drawing equipment. Here you can see tracing paper, a scale, set square, masking tape, pencil and tape measure.

To produce a scaled drawing, at say 1:50, is simple. Measure the length of a wall. Let's say it is 2m long. Pick up your scale and mark off 2m as shown on the 1:50 scale. That's it. You can now complete your drawing by repeating the process and marking it on your plan. You would have noticed other scales are available on your scale rule. But for the time being, 1:50 is ideal for drawing houses and apartments as they fit nicely on an A4 or A3 piece of paper. Using a scale and tracing paper is a good way to start – but soon, you will want to use a 3D modelling computer program.

Note

1 Some of the drawings in this book are not drawn to scale; they were not intended to be. They are merely freehand sketches. Others were drawn at 1:50 scale but have been reduced during the printing of this book.

2 All other design drawings satisfied the Local Authority Building Control and Planning requirements at the time of approval. As a result, only very modest modifications were made on-site following Local Authority inspections.

3 It is acknowledged that, despite regular reminders, builders do not always use appropriate safety equipment, for example, boots and helmets. This is an unacceptable practice. However, I am pleased to report that safety standards continue to improve year on year, which continues to make a positive contribution to the UK's construction safety record. All work should be carried out in accordance with health and safety requirements.

4 Red shaded areas on drawings denote new work.

FURNITURE & FITTINGS

I have included a few samples of furniture and fittings that I have purchased and specified for clients. You can reflect on the merits of these. But, of course, it is a matter of personal opinion, and context is a determining factor. And it's not simply a question of selecting items – it's more to do with how they integrate into the overall design that really counts. In that sense, it's rather like the classic swing song, 'Tain't What You Do (It's the Way That You Do It). You can also see instances of general, task and accent lighting. I recall working on a student project and keen to make the lighting a feature of my design. I asked my design tutor, 'I don't know where to put the lights?' He replied, 'where do you want the shadows?'

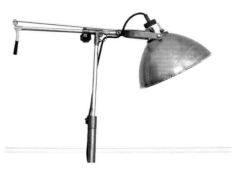

Task lighting. This 1950s adjustable lamp with a chrome dish provides excellent light for reading.

Accent lighting. This fitting is focussed on the column and creates atmosphere by producing light and shade.

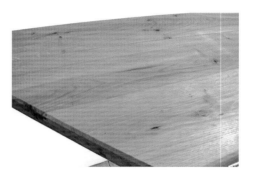

Solid oak work surface is made from double thickness tongue and grooved floorboards, screwed together and supported by oak brackets.

Natural leather sofa with a curved profile. Leather sofas can last three times longer than a fabric equivalent.

Frameless glass coffee table. Think carefully about this – its transparency has been responsible for bruised ankles!

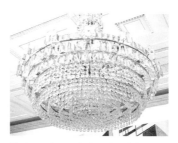

Traditional crystal glass chandelier is designed to be a focal point of a room.

White Venetian blind. The slats are very good at reflecting light around a space.

Personal items have a special place in our hearts.

Cast iron traditional radiator with a gunmetal finish. A bolt secures the radiator to the wall.

General lighting. Aluminium alloy circular wall light with opal diffuser provides excellent overall lighting conditions.

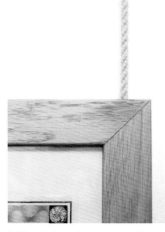

Solid oak picture frame with excellent mitre joints. It is fixed to the picture rail with rope.

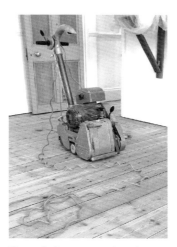

The sander has cut approximately 1mm from the top of the pine boards, ready for 3 coats of semi-matt varnish.

Attractive antique oak table.

It was heart-warming to see my landscape gardener walk through my flat with a fully planted flower box and place it on my cill.

Flower Box Design
CASE STUDY **1**

Why do this project?

This is an ideal first project for your new home. If you have elementary carpentry skills, you may want to create a few flower boxes yourself. If not, you can readily get them made up and arrange for them to be planted. They bring a lot of joy for such a small object, especially for those home owners without gardens and balconies. I usually add a few bulbs each year during October.

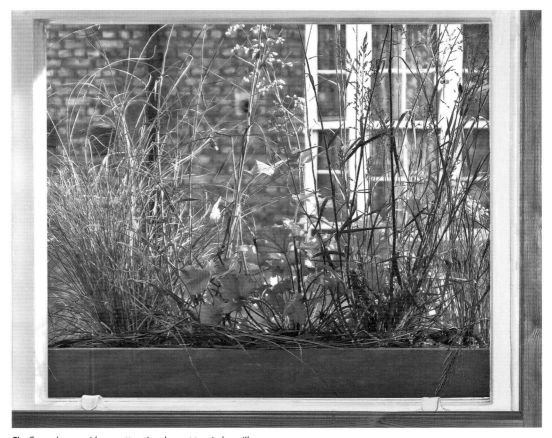

The flower box provides an attractive element to window cills.

What is it about?

There are two problems. You can buy a standard box from a garden centre. Some are made from non-biodegradable materials and pose a problem of disposal. Secondly, off the shelf boxes come in standard sizes, which are unlikely to match the width of your window. A gap on either side is unsightly and limits planting.

Which techniques are used?

Marine-grade plywood is an excellent material. It's used in the shipbuilding industry and made of good quality hardwood — each layer stuck with waterproof glue. I specified 15mm plywood, carbon capture compost with a polythene lining and finished with bio premium wood oil. Galvanised retaining chains were used to secure the boxes to the cill.

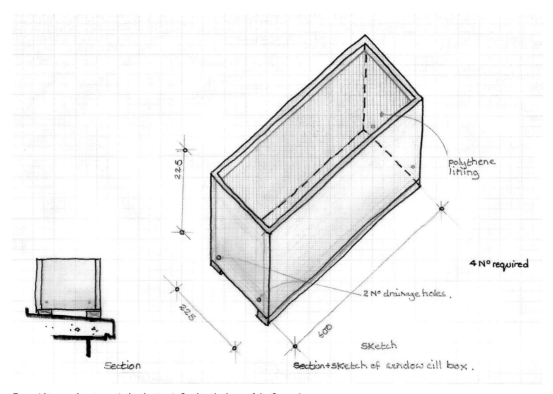

To avoid trapped water, a timber batten is fixed to the base of the flower box.

Wood bark has been added on top of the compost to reduce evaporation.

How did it work out?

It's a great little project. My boxes have attracted the attention of butterflies and bees, and I always find it fascinating to see what comes up. They have inspired others in my area to do likewise.

The size of the box was designed to give maximum planting with minimum wastage of materials.

I wanted to get rid of the horrid lightweight doors with unsightly door handles and get back to the original panel doors that beautifully reflect the character of this Victorian property.

Internal Door
CASE STUDY 2

Why do this project?

Doors provide access but also enhance the quality of an interior. I purchased my second Victorian terraced house and was faced with a building that needed a lot of work to turn it around. Apart from anything else, I discovered, shortly after moving in, that the property had fleas from the previous owner's cat! This was quickly sorted out by the local council. Vandalism and the previous owner's curious decision to dispense with the original panel doors favouring a mix of look-alike flush and veneered modern filled me with apprehension. If you were to open up these doors, you would discover they contained only a small percentage of wood and had an egg-box structure. They were lightweight and offered little resistance to impact damage and noise transmission.

Original panel doors, by contrast, come in many forms but essentially consist of four, six or more panels. Their visual qualities depend on their material, size, finish and level of decoration. The structure of the door is made of solid wood with the panels either wood or plywood.

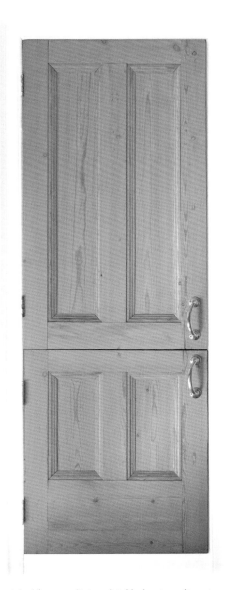

This original four-panel internal stable door is used to gain access to specific shelves inside this cupboard. It is fitted with stainless steel handles.

What is it about?

Sorting out the doors would be my first project at this house. I wanted to remove these modern 'look-alikes' and reinstate doors more suited to the character and period of my Victorian home. I had freedom of choice about the physical appearance of the doors because there were no Building Regulation requirements. But it is worth remembering that there are circumstances that require a door's specification to be upgraded. For instance, a change of use or the creation of a loft conversion will almost certainly need some new and existing doors in your property to be fire resisting and self closing. The doors will fall into the category of FD30, i.e., able to withstand the action of fire for 30 minutes. Backed up by independent testing and fire certificates, they will also provide some protection against smoke and dangerous fumes. New developments in fire safety include Fire Suppression Systems, which offer new ways of restricting fire development.

Which techniques are used?

If you are sold on the idea of original panel doors for your home, you should make contact with your local Architectural Salvage Centre. They also store doors from the 1930s, so even if you have a 60s home, you will have plenty of choices. A door stacked beside many others in a dark and cold warehouse will not appear in its best light – but it's amazing what a bit of tender loving care will do. Outlets outside city centres will probably have the best offers, and you will find a good selection of doors that can be cut to size. Some providers offer a comprehensive service and will remove the existing paint for you. But you may prefer to do this work yourself. If you want a natural timber look (and I think that looks best), it's easy. Apply some paint remover and later sand with coarse and fine sandpaper followed by clear beeswax – all in accordance with manufacturers' recommendations. You will also need to consider the door's ironmongery, including handles, kick plates and door stops.

How did it work out?

The robust construction of an original panel door will provide excellent fixings for hinges and handles and create an impressive feel. I don't have a problem with original panel doors fitted with contemporary door furniture. You can see here an example of a door that has been damaged and repaired with a diamond-shaped insert. Some may feel this spoils the appearance. I take a different view and feel it's interesting to see the evolution of the door over time – this original door forms part of a building that was created in 1890. It's refreshing to see it in use today (amazing to think this door was hanging in a home while bombs were dropping from the sky during the London Blitz!)

As you close a solid wood door, you will be aware of its density and weight – qualities missing from lightweight alternatives. It looks great too! Some would say that it is perverse to paint wood, especially when you consider that wood, itself, is intrinsically such a beautiful material. You decide.

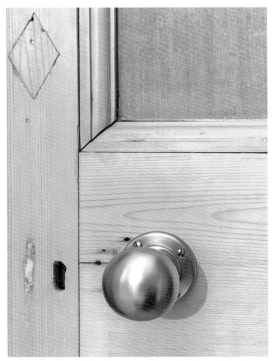

A diamond of wood has been inserted into the face of this door which is fitted with a contemporary door handle.

———

Making a purpose-made storage unit means that it can be designed to meet your needs and reinforce the visual qualities of your home.

———

Storage Cupboard
CASE STUDY 3

Why do this project?

Storage, its extent, location, ease of access and design needs to be taken very seriously. Because I prefer simple, uncluttered interiors, it is crucial that my storage requirements are met and that the design complements the character of other elements within my apartment. In this case study, I am seeking to provide a storage space that specifically satisfies my requirements, has excellent visual quality and reinforces the character of the interior.

What is it about?

Looking online, you will discover you are spoilt for choice. Some cupboards come in the form of flat pack furniture – they are easily transported and assembled at home. They are generally made of engineered wood consisting of wood chip and resin with a melamine face. Melamine is a thermosetting plastic material that can be mixed with paper to give the appearance of wood. But if you want it to look like wood; why not use wood?

A better way forward is to design a purpose-made product that will fit the space available with shelving to suit. It can be designed to colour match other items in your home. Wood is a remarkable material; it's easy to cut, looks great and has a high strength to weight ratio. Better still – it can be recycled.

Which techniques are used?

In general terms, door panels at the top of a four panel door are taller than those at the bottom. For this reason, you will need to buy two identical doors from your recycling shop. If you hunt

around, you can buy these at a competitive price. As shown on my isometric sketch, you need to cut the same portion from both doors to make a pair. (The remaining part of both doors can be put aside and used to make a second cupboard.) A filler piece of wood on either side of each door may be required. I created three shelves inside, of different heights, to match my requirements – you can see the benefits of purpose-made design!

While I was at the salvage shop, I also purchased some antique floorboards for the top of the cupboard that would be identical to the width of my existing pine floor. To begin with, I bought one board and took out my key ring to scratch its surface. I was checking it matched the colour of my existing floor. It did – so I purchased the rest to complete the project. Finally, the doors were hinged, the entire cupboard sanded down, beeswaxed and door handles fixed. Done!

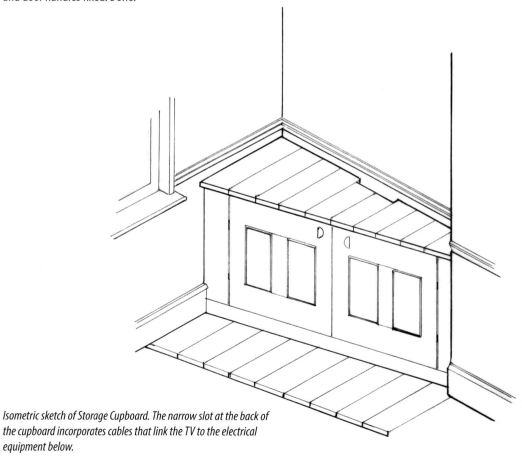

Isometric sketch of Storage Cupboard. The narrow slot at the back of the cupboard incorporates cables that link the TV to the electrical equipment below.

How did it work out?

It is good to see the cupboard has a complementary relation-ship with the interior of my apartment. It also perfectly fills the gap and provides a useful storage space whilst offering an excellent surface to place the TV and sound reinforcement speakers. But be very careful with the information you hand to your builder, particularly if it is in the form of a drawing. They take the information seriously, and it forms the basis of their price for the job. What's more — the builder will construct what you have drawn!

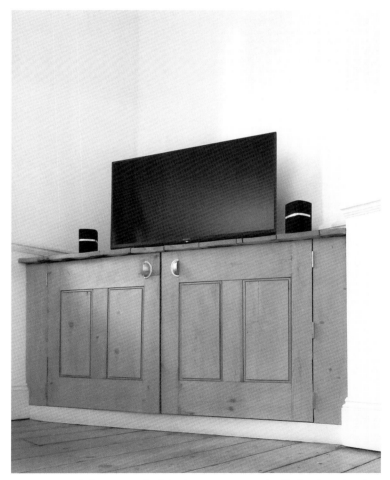

If there are practical difficulties to be solved — and there often are with old buildings — I usually say to my builders, 'get as close as you can to achieve the visual effect described by my drawing'.

Bear in mind that if you have elementary carpentry skills, you could build the storage cupboard yourself, reducing costs by approximately 60%. The cost of improving your home is strongly influenced by the cost of labour. If you do some of the work yourself, you not only save money but guarantee good progress and ensure that the work is done at a convenient time for you.

Storage Cupboard. The isometric sketch for this project was completed before the cupboard doors were selected at the salvage shop. This accounts for the slight difference in appearance between the drawing and the build.

35

It's a horror show to experience water damage but the lounge was brought back to life and became an attractive space.

Lounge Refurbishment
CASE STUDY 4

Why do this project?

While I was away, the failure of an incoming water service to a first floor shower resulted in severe damage to the property. Whilst little work needed to be done to the bathroom, it was clear that significant refurbishment was required to the ground floor lounge. Building insurance covered the cost, but the inconvenience was considerable, and a positive response was required.

What is it about?

Part of the lounge had a suspended timber floor. The other half of the floor nearest the rear garden was solid and made of concrete. The plan was to get the property back to its original condition. Still, the reinstatement of the space did provide the opportunity to incorporate an effective damp proof course to the suspended floor and a damp proof membrane to the solid floor.

Which techniques are used?

A builder was appointed to carry out a series of tasks. The solid floor was relayed and provided with 50mm of screed, laid flush with the top of the new tongue and grooved floorboards, which were supported by new floor joists. The entire floor was provided with a carpet finish. The walls were plastered, the ceiling provided with plasterboard and skim. Later the walls

and ceiling were decorated with three coats of ivory emulsion paint. Work to the upstairs bathroom merely consisted of replacing a small section of timber wall, plasterboard with a plaster skim coat and redecoration.

How did it work out?

There are positive and negative aspects to this project. It was great to replace the slightly uneven floor and shadowy plaster with a new finish. The slight damp problems were resolved, and it's always a joy to have a freshly redecorated space. But this event caused significant damage to the back of the house. Half of the property was unusable for approximately six weeks. Arriving home to discover water bouncing off the hi-fi system did not exactly make my day. During a call to the insurance company, the adviser said, 'move the soaked carpet and put it outside'. Move it; I couldn't even lift it!

But it worked out fine. I was left with a new space, perfect for listening to music with great views of the garden. Unfortunately, this is not the only time I have experienced water damage – it is always likely to happen when working on properties. So I strongly recommend you ensure everyone in your household knows how to turn off the water supply. Also, get an annual contract with a plumber that will secure a prompt service in the event of a problem. And remember, never nail down a floorboard without lifting it first to check for pipes. And if, while nailing a board, you hear a 'psst sound', leave the nail in position. Do not remove it and contact your emergency plumber. And don't, as I have, end up dealing with this sort of problem at 10 pm on a Sunday evening!

The water feed to the shower head failed, leading to severe flooding.

Increased moisture in wood causes flaking paint.

A dehumidifier was used 24 hours a day to reduce moisture content.

The ceiling and walls were damaged and the carpets ruined.

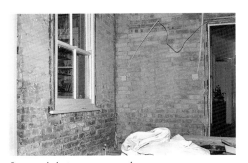

Damaged plaster was removed.

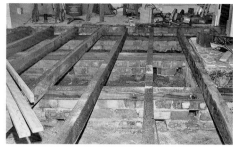

The new suspended floor consists of treated floor joists supported by sleeper walls.

The existing space has a suspended and solid floor.

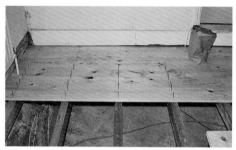

New tongue and grooved boards are in position and nailed to new floor joists with ring shank nails. These nails have grooves around their shank for superior grip.

The 100mm pipe on the solid floor provides ventilation to the suspended timber floor.

Delivered materials include bonding and finish plaster, scrim, plasterboard and nails. Scrim reinforces plasterboard joints and reduces cracking.

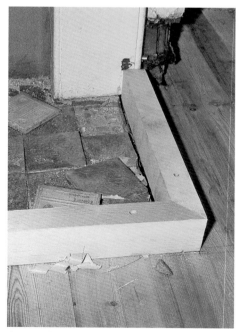

A surround to the fireplace has been secured with an excellent mitre joint.

The builder was surprised to discover an incoming water pipe in the corner of the room.

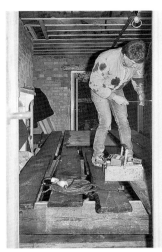

Plasterers working from a platform scaffold.

This tube of lead is one of two counterbalances that support the weight of a sash window.

A damp proof membrane has been applied to the solid concrete floor – the walls have received a first coat of plaster.

More thought needed to be given to this arrangement of waste pipes; visually, it looks messy.

Walls were decorated with three coats of emulsion. The first coat was a mist coat with 10% water added.

———

*An external space is a joy – it reduces stress levels
and makes us feel more relaxed.*

———

Garden Terrace
CASE STUDY 5

Why do this project?

An external space has many benefits. It is a private haven, separate from the restlessness of everyday life and ideal for relaxation and conversation with friends. If you have visited Builders' Merchants, you will have spotted pretreated timber decking. It has been used for patios throughout the UK and comes in standard widths. I wanted to explore an alternative approach that used rough sawn timber.

What is it about?

Rough sawn timber has not been planed and has unfinished surfaces from when it was cut by a circular saw. The roughness of its texture soaks up timber preservative, which provides excellent protection. I think it also looks great and suppliers offer a variety of colours to choose from. So you can see I have been very courageous with my choice of colour – some would say foolhardy!

Be careful when handling rough sawn wood – it's easy to get splinters, so gloves are essential. I prefer to lay the boards with a gap of 10mm between each. Stepping on the boards and looking down reminds me of the joy of a stroll on a pier and looking down through the gaps in the boards to the sea below. Well, I can't offer you a view of the sea, but you will catch a glimpse of the pea shingle, which looks particularly impressive after rain. It's an effective weed suppressant and also enhances security. The sound of shoes on its surface pre-warns home owners that a visitor has crossed the boundary of their home.

Which techniques are used?

Timbers were secured with powder coated black bolts, and the boards nailed in place with ring shank nails that have grooves around their shank, offering a superior grip. In addition, the gaps between the boards help drain the rainwater and provide a non-slip surface.

How did it work out?

Completed in a couple of weekends, it was a joy to work on and became a great place to sit and have a cup of tea. Just in case you are thinking – no, the neighbours didn't complain about the colour, and it did tone down after a year or so. In fact, it was a good choice. The colour provided a vivid backdrop and, counter-intuitively, emphasised the planting.

Space was allocated for the delivery of materials.

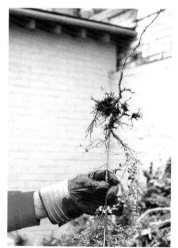

The derelict shed at the back was demolished. Topsoil was removed from a small rectangle of land at the rear of the property.

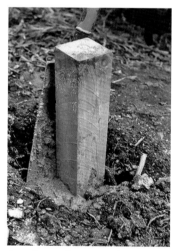

A small excavation was made to accommodate the timber posts with polythene wrapped around their base beneath ground level.

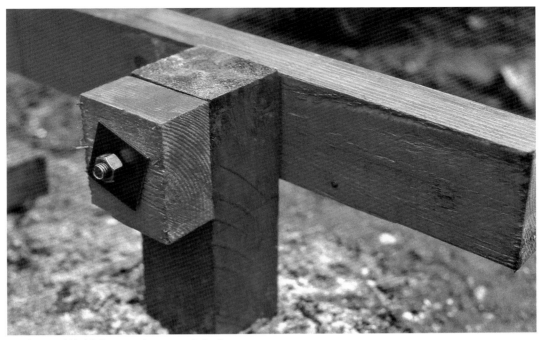

Powder coated black bolts secure the post to a timber bearer.

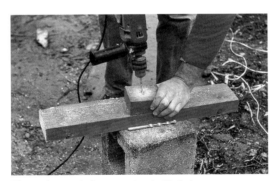

The rough sawn timber was painted with timber preservative - all timbers were given two coats.

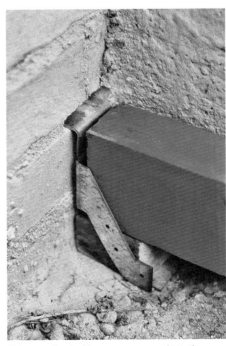

This pre-galvanised hanger was recessed into the brickwork and fixed in place to receive a timber bearer.

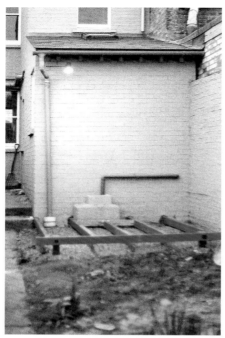

The frame is now in position; beneath is 10mm pea shingle.

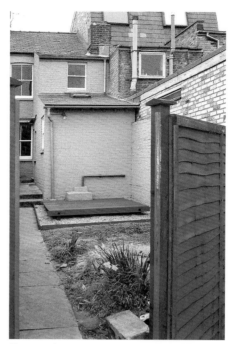

The general arrangement is now complete.

The bed of pea shingle is bordered by a timber surround.

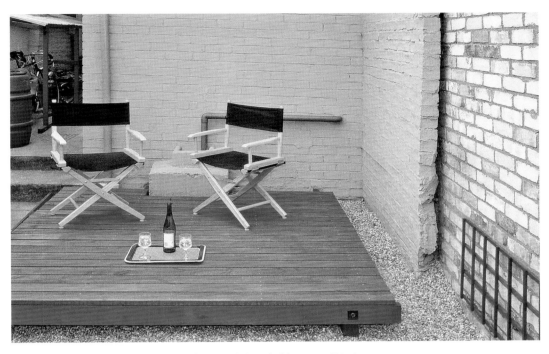

Two directors chairs and a celebratory bottle of wine mark the end of this project. Enjoy!

This bicycle store used the same construction method and has translucent roofing.

Pea shingle was also provided to the front of the house.

47

You can spend £8K on a mid-range kit-out. My design cost a tiny fraction of that figure and provided an excellent place to hang clothes and increase storage capacity.

Walk-in Wardrobe
CASE STUDY 6

Why do this project?

Home owners vary in their storage requirements. This project aimed to modify the size of the existing bedroom in favour of a walk-in wardrobe. This would allow redistribution of stored items throughout the apartment.

What is it about?

The wardrobe would be used to store clothes and other personal items, and a ladder would provide access to the shelving at a high level. It involved demolition, the construction of a new non-load-bearing wall, plasterboard and skim, door hanging, shelving, decoration and a new light fitting and switch. It is essential to distinguish between non-load-bearing and load-bearing walls. In the latter case, it's worth noting that openings can be made, but lintels (beams) need to be provided above the opening. If you have any doubts about this, you should consult a structural engineer.

It has to get worse before it gets better. A small part of the right hand wall has been demolished to increase natural light into the corridor.

Which techniques are used?

It is important to remember that whilst you are familiar with your design, a builder sees the arrangement for the first time. For this reason, it is good practice to help them prepare their quotation by providing a plan drawing plus a Schedule of Work. This describes items of building work that your builders can use to record their price. Of course, all builders must be given the same information. It is only then that a sensible appointment can be made based on cost. In general terms, you should accept the cheapest. If you are not confident in your builders carrying out the work, you shouldn't have included their name for a quotation in the first place. I usually invite four builders to quote.

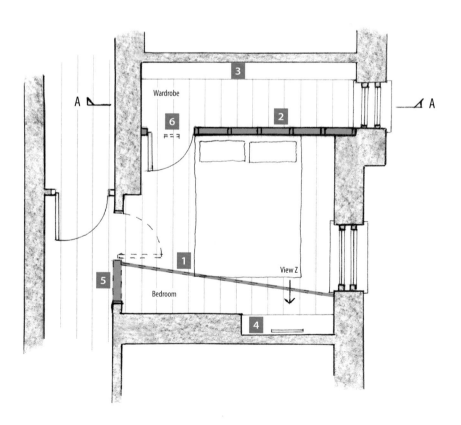

Plan of Bedroom Walk-In Wardrobe

Schedule of Work

Items **1** to **6** refer to numbers on the plan drawing.

1 Remove existing thin partition.

2 Construct a new walk-in wardrobe, 100 x 50 mm timbers at 450 mm centres, plasterboard and skim both sides. Existing bedroom door to be repositioned to new walk-in wardrobe with new circular light fitting above.

The specification called for the door to be fixed in position with timber framing, ready to receive 12.7 mm plasterboard, skim and decoration.

3 Fix 5 new shelves 275 x 25mm supported on brackets.
Bottom shelf to be provided with clothes rail.

4 New solid oak shelf and bracket for the TV.

5 Increase width of entrance by removal of existing partition.

6 Relocate door and fix new light fitting, switch and cable.

Note:

All materials for bedroom shelving and brackets, light fittings and brass hinges to be provided by client.
The home owner's belongings will be removed to provide easy access.
Each builder to list prices and confirm start date.

I have summarised details of the Schedule of Work for this project. It should be read in conjunction with my Plan for a walk-in wardrobe, Section AA and elevation View Z. I suggest you provide a plan and Schedule of Work for your projects.

Section AA

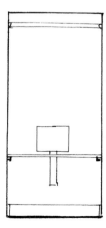

View Z

How did it work out?

The selected builder wanted to avoid wet trades by omitting the application of a skim coat of plaster to the new timber wall. Instead, he favoured merely applying thick lining paper directly to the plasterboard. This did not work out well, and I regret agreeing to his suggestion. It did not provide a flat surface – especially between the plasterboard joints.

I wanted to mark the fact that, unlike all other spaces in my apartment, the new wardrobe would be used for storage only. Whilst other spaces would be used for key activities like relaxation, food preparation and so on – the wardrobe was merely a storage area. For this reason, I decided to paint the inside walls a colour to differentiate them from other, more important 'lived in' spaces. I chose green which would echo the colour of rubber flooring in my kitchen and bathroom. This contrasts with the rest of the apartment, which has white walls. As shown in the photographs, the exact shade of green was achieved digitally in the paint shop. But be careful here. The digital camera can be misled by a glossy surface. A result that is not an exact match, or even a completely different colour, is the worst outcome.

The wardrobe has been a successful venture and provides an excellent place for storing clothes at a very modest cost. In addition, the natural light from the existing window offers a strong deterrent for moths that cause damage to fabrics.

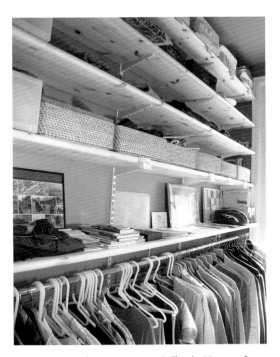

Five shelves were fixed in position and offered a 20m run of new storage space. In addition, the bottom shelf was provided with a full-width clothes rail; the wall painted green to match the floor colouring in the bathroom and kitchen.

It seems curious to have a split level bathroom
but the design has practical benefits.

Bathroom Design
CASE STUDY 7

Why do this project?

I moved into a three bedroom property which was let down by an untidy bathroom that required a complete redesign, including the replacement of all fittings. I was looking to increase the size of the space and create a simple arrangement with detailed consideration of all aspects of the design.

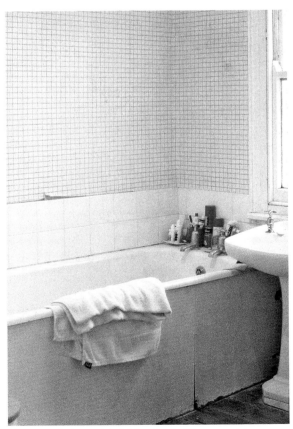

The existing fittings and the left hand wall will be removed. A new timber wall will be built 1.1m further back and this will increase the space for the new bathroom.

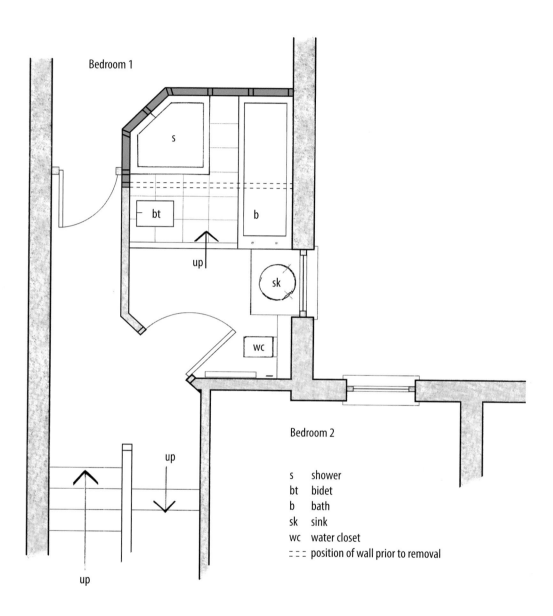

Bedroom 1

s

bt

b

up

sk

wc

Bedroom 2

up

up

up

s shower
bt bidet
b bath
sk sink
wc water closet
= = = position of wall prior to removal

Plan of New Bathroom

What is it about?

My brief called for a new WC, bath, shower, handbasin and bidet. After trying out a few ideas, I came up with a layout that separated the facilities into two separate areas. The WC and handbasin were designated as a 'dry area' and provided with grey showerproof carpet. The shower, bidet and bath were placed in the 'wet area' and had waterproof grey rubber flooring. This separation of function was reinforced by creating a change in level, which has practical benefits. Because the bath and shower tray both sit on the existing floor level, it's much easier to enter the bath from the raised floor. Also, the top surface of the shower tray is flush with the new raised floor, which avoids something we have all done, stubbing one's toe on a hard surface! So this arrangement ensures that the bath and shower can be easily accessed, and this may well be an attractive feature to a purchaser when it comes to selling the property.

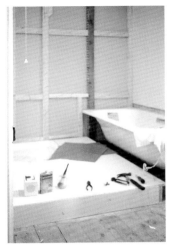

A new bath has been installed at right angles to the existing, and a single step produces a change in level. The new timber stud wall is now in position with some existing timbers reused.

Only a limited number of the 150x150mm tiles were cut.

The new timber wall is now complete and is being plastered on the bedroom side.

There is another aspect to this design that is distinctive. As far as possible, the layout is fixed by whole-tile dimensions. For example, the bath is three tiles high and seven tiles long. The step is one tile high. You can see examples of this in the build photos. Of course, it's impossible to achieve this in all situations – it is, after all, an existing space. But it is good to limit the number of cut tiles; it reduces wastage and improves the appearance of the tiling. Thin cut tiles look ugly and break over time.

Which techniques are used?

The realisation of a bathroom or kitchen is more complex than, say, a lounge or study. Kitchens and bathrooms require several different trades working together, including electricians, plumbers and builders. It's all got to happen in the correct order with tight control over the quality of work. Managing the process is vital; it's a case of always planning ahead and anticipating problems.

The new timber wall consists of 75 x 50mm timbers at 450 centres (i.e., the vertical timbers were spaced with their centre lines 450mm apart) with plasterboard on both sides. I favour fixing plasterboard not with nails but with black pozidriv countersunk heads because they are less likely to disturb or damage the stud wall. The bedroom side was given a plaster skim coat and decorated with emulsion paint; the bathroom side had tiles laid directly onto the plasterboard.

How did it work out?

I managed the project on a day to day basis, and it went very smoothly. I recognise that many would say this design looks austere and would prefer something more welcoming. It's not easy to photograph because of the absence of busyness, and the space itself is the crucial ingredient. You can make up your own mind on this. The shower and bath did offer a hint of luxury; my bathroom had been transformed from an

unattractive and rather grubby edifice into a light and hygienic space. The raised floor worked well and provided an excellent space to hide the 38mm waste pipe from the shower and bath. I arranged for an estate agent to visit after this work had been completed. Clearly, my intervention had increased the saleability and value of the property.

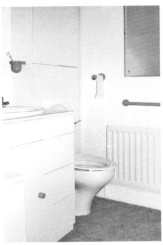

The existing level of the bathroom has a grey showerproof carpet.

The arrangement was designed to limit the number of cut tiles, which achieved economic, aesthetic and practical benefits. Notice the step is precisely one tile and the bath three tiles high.

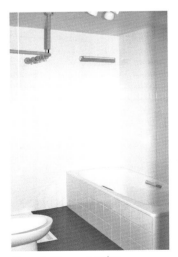

The project is now complete, ironmongery has been fitted, and rubber flooring laid.

I was pleased with a comment from a lady who lived opposite. She said, 'I know you have been doing some building work – but where's the extension?'

Loft Conversion
CASE STUDY 8

Why do this project?

I bought another terraced house in 1986. It was built around 1900 and was located close to Cambridge City Centre with beautiful walks beside the River Cam. As the existing ground and first floor plans show, the entrance door to the property leads directly into the lounge with one step down to the kitchen. An existing stair leads to two bedrooms and a new bathroom which was part of the first phase of the development of this property.

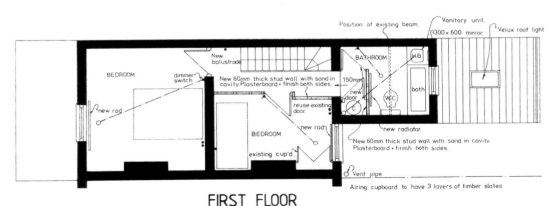

FIRST FLOOR

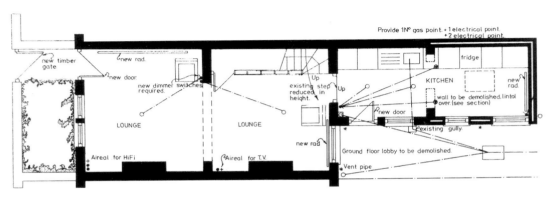

GROUND FLOOR

Existing Ground and First Floor Plans

Loft conversions have a lot going for them. They produce distinctive spaces, outstanding opportunities for getting natural light into a space and provide their users with great views. You will realise some extra space in your home and avoid the hassle of moving. It's an obvious way of developing a property, but it does need to be handled with skill and sensitivity.

On the first day of ownership, I had arranged for builders to start work at 8.30 am. I arrived at 8 am to discover they had already gained access. You might be surprised to hear they had broken in by climbing up the back kitchen wall and sliding the catch to the first floor bedroom window. But, something you might be even more surprised to hear – I was delighted! They had arrived and wanted to get on with it.

The first phase of this development included central heating, roof insulation, and a new kitchen and bathroom. It needs emphasising that this work was done on a very tight budget, and my contribution in the form of demolitions, tiling and decorations reduced costs by about 35%.

What is it about?

A few years later, I took on the second phase of the work, which involved removing the pitched roof over the main body of the house and replacing it with a new structure at a steeper angle. The roof was lifted by approximately 1m to create sufficient space for a third bedroom. My design concept for this new project was based on the idea that the extension should have a positive relationship with its broader context and adjacent buildings, and I was prepared to limit the volume of the space to achieve this objective.

The plan of the loft and Section AA show the design of the new space, including, in plan, the new stair. As you can see, there are two large roof lights to the new loft space, a circular window in the stair partition and a steel ladder which provides an

alternative means of escape. The Building Control Officer required this because the means of escape at the ground floor was unacceptable. When a house is changed from essentially a two to three storey building, the safety requirements become more stringent.

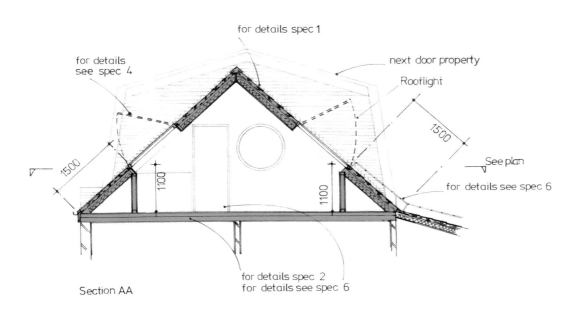

for details spec 1

for details see spec 4

next door property

Rooflight

1500

1500

1100

1100

See plan

for details see spec 6

Section AA

for details spec 2
for details see spec 6

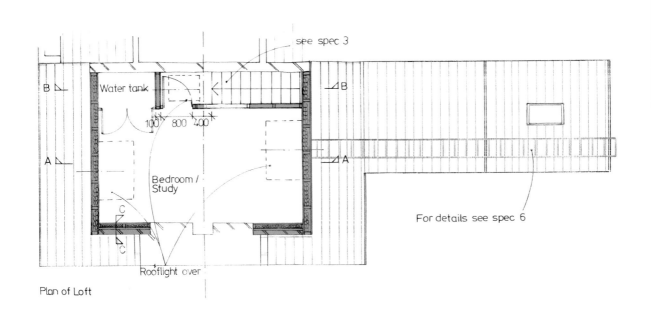

see spec 3

B

Water tank

B

100 800 400

A

A

Bedroom / Study

For details see spec 6

C

C

Rooflight over

Plan of Loft

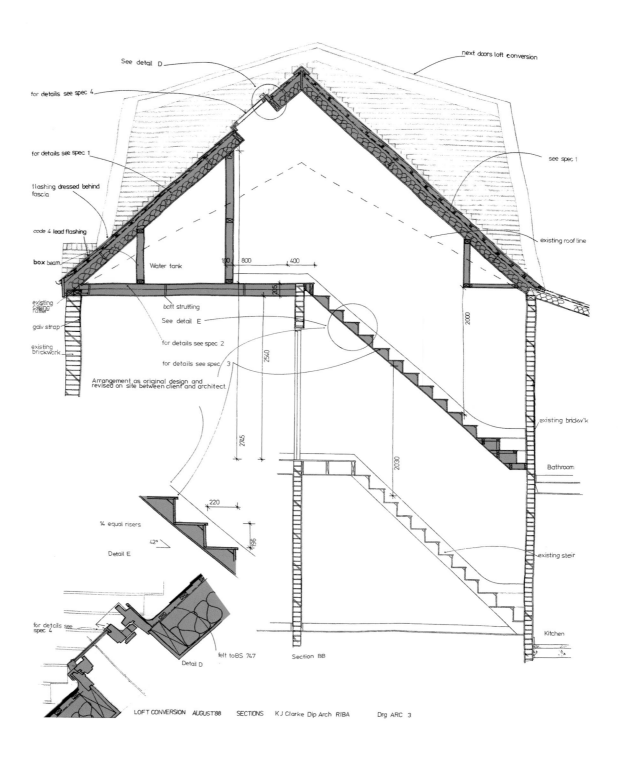

See detail D

for details see spec 4

next doors loft conversion

for details see spec 1

see spec 1

flashing dressed behind fascia

code 4 lead flashing

box beam

Water tank

existing roof line

existing ceiling rafter

batt strutting

See detail E

galv strap

for details see spec 2

existing brickwork

for details see spec 3

100 800 400

205

2000

2540

Arrangement as original design and revised on site between client and architect.

2745

2030

existing brickw'k

Bathroom

220

14 equal risers

196

existing stair

42°

Detail E

Kitchen

for details see spec 4

felt to BS 747

Detail D

Section BB

LOFT CONVERSION AUGUST'88 SECTIONS K J Clarke Dip Arch RIBA Drg ARC 3

The existing ceiling was cut to accommodate the new stair. Box beams were fixed above new floor joists to provide additional support to the ceiling rafters. The box beams consisted of plywood sheets fixed on either side of 100 x 50mm timber framing in the form of a ladder. Miscellaneous work included fixing new tongue and grooved floorboards, radiators, repositioning the storage tank, plastering, and decorations. After my builder left, I carried on with the build by fixing insulation, plasterboard, floorboards and decorations.

Section BB shows a large vertical slice through the entire house and includes the existing roofline in relation to the new roof height. You can see the neighbours' mansard roof extension and the line of the new stair with the small rooflight above. A lot of thought went into the interior design, including bullseye spotlights, new pine tongued and grooved floorboards and a reclaimed timber door. A grey futon sofa bed was specified for the new loft space, the walls painted with ivory emulsion paint. Treads to the new stair were wrapped in lime green carpet, and blinds were fixed to the rooflights with remote operation.

The staircase details drawing shows a Scandinavian influence in the design of the handrail and balustrade. The arrangement includes an update on the staircase design with a 100mm gap in the riser to the stair. This allows light to filter down to the lower levels.

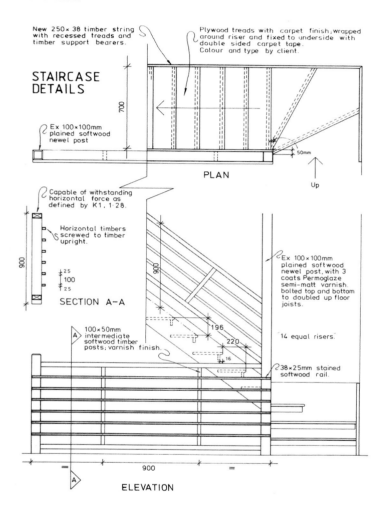

The rear elevation drawing reveals the extension in relation to neighbouring properties and defines the route of the steel ladder from the rear rooflight. Whilst providing an alternative means of escape, it did represent a security risk. For this reason, the ladder does not reach the ground floor, but can be made to do so with the aid of a bottom section that is hinged. Notice the 'buffer,' Detail D, at ground level to catch the ladder. The arrangement was made up by a specialist steel fabricator and arrived on-site painted with corrosion resisting paint.

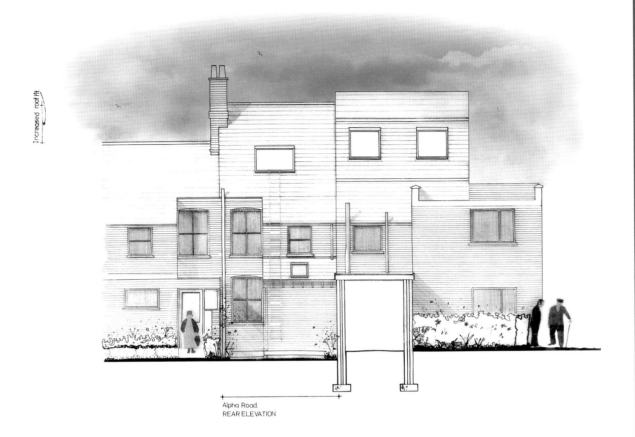

Increased roof ht

Alpha Road.
REAR ELEVATION

Hinged detail of fire escape ladder

Lower section here hinged at this point for security – prevents direct access to rooflight from ground floor.

DETAIL D

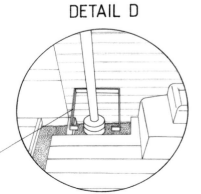

Base detail of fire escape ladder

Mild steel buffer to catch hinged section in event of fire – bolted with 2N° 12mm rawlbolts to existing brickwork.

Which techniques are used?

The circular window is of particular interest. Standard windows from suppliers were small and unimpressive. So I designed a large purpose-made window made up in a workshop, and it was delivered to the site. The window consists of five sections which were cut from wide pieces of timber — each segment fixed together with glue and dowel.

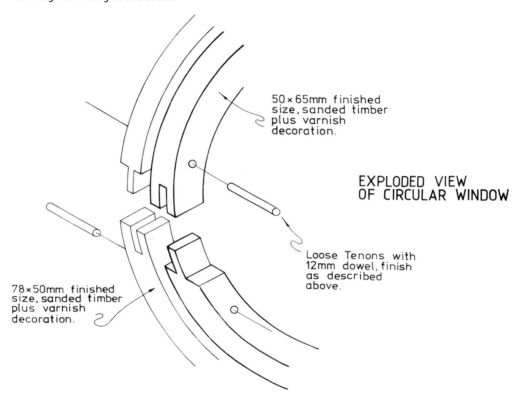

50×65mm finished size, sanded timber plus varnish decoration.

EXPLODED VIEW OF CIRCULAR WINDOW

Loose Tenons with 12mm dowel, finish as described above.

78×50mm finished size, sanded timber plus varnish decoration.

How did it work out?

The loft space rooflights were too large, and the space became warm during hot spells. I should have specified antique floorboards rather than standard softwood — they would have looked better. And I should have dimensioned the position of the small rooflight over the new staircase. It was positioned by the builder and was not centred on the staircase below. Since the completion of this project, Fire Suppression Systems, referred to earlier, have been developed which extinguish, contain or entirely prevent fires from spreading.

But I was satisfied with the design. I recall some wonderful early mornings and late evenings in the loft space with views over Cambridge. It was great to lie down on the futon and gaze through the large rooflights and beyond into the night sky. I was also pleased with a comment from a lady who lived opposite. She said, 'Keith, I know you have been doing some building work – but where's the extension?'

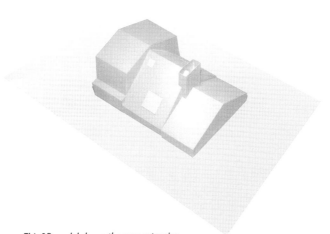

This 3D model shows the new extension in relation to neighbouring roofs.

Scaffolding was erected, and the builder started removing slates.

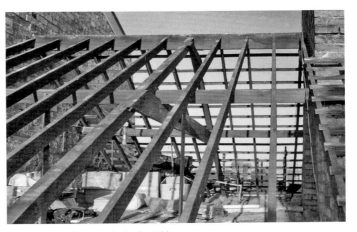

The existing roof structure is clearly visible.

The existing roof structure was retained in position and used as a platform to create the new structure.

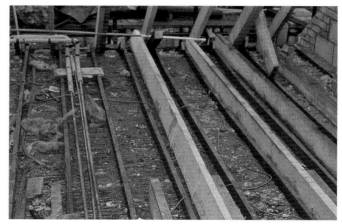

New floor joists have been secured in place beside existing ceiling joists.

Bricks were laid with mortar to match existing.

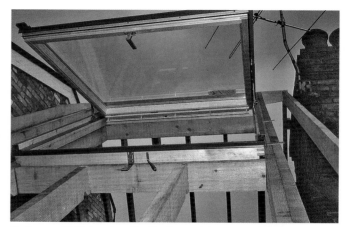

Top hung rooflights have been fixed in place, and these are specifically designed for means of escape purposes.

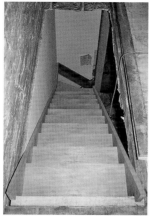

The new stair has been fixed in position.

Between the new ceiling rafters were placed thermal insulation batts with a 50mm airspace for ventilation. The work was carried out by quality tradesmen.

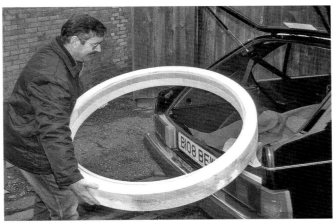

The new circular window was delivered to the site; it was beautifully constructed.

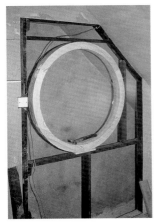

The new circular window has been fixed in place.

The roofer prepared the slates for fixing.

The base of the new stair.

The project is now complete. New tongue and grooved floorboards have been painted with three coats of semi-matt varnish.

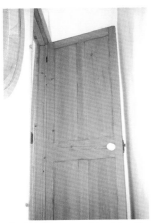

The door at the top of the stair with a porcelain door handle and circular window on left hand side.

It was time to harness technology and design a new space providing high levels of comfort – even during hot summers and freezing winters.

Single Storey Extension
CASE STUDY 9

Why do this project?

My family home consisted of a 1930s house in a leafy suburb, some two miles from Wimbledon in south London. An extension was added during the 1960s. It was a gas guzzler — too hot during the summer and too cold during the winter. I used to joke to my family that, during hot summers, there were only a few minutes in the day when the extension was usable. The building had low thermal mass and was disproportionately affected by environmental conditions.

Nevertheless, this lightweight structure survived surprisingly well. It withstood everything nature could throw at it, including the storm of October '87. As a result, I have fond memories of this space and its part in our family life.

What is it about?

It was time for the old extension to be replaced by a new one offering quality environmental conditions by being packed full of thermal insulation and needing only a small radiator to achieve ideal comfort levels. The space would benefit from lots of natural light and include a shower, ground floor toilet and a study with direct access to the garden. This would provide excellent opportunities to observe the local wildlife.

Which techniques are used?

With the arrival of modernism around the 1920s, the concept of structural honesty was born. Architects wanted to reveal the

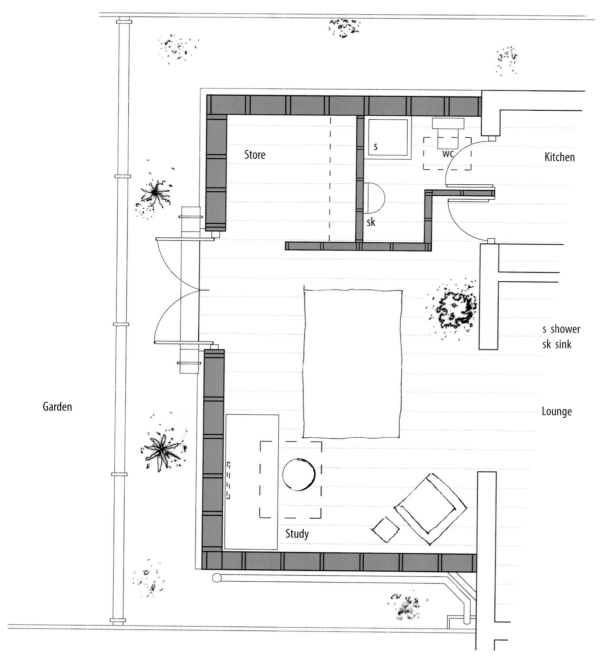

Garden

Store

S

WC

Kitchen

sk

s shower
sk sink

Lounge

Study

Plan of Ground Floor Extension

bones – the structure of a building. With this project, I chose to expose the roof structure internally and externally, making it an important design element. This was a big decision. It would make a considerable impact on the overall appearance and be a feature of the interior. Later the exposed wood was painted with clear fire resisting paint to resist surface spread of flame, and I was pleased to see that this did not affect its visual quality.

Timber walls, rather than masonry, added to the ecological credentials of the design with cavities packed full of high performance insulation. But note – in a situation such as this, it is vital to record the timbers' position to achieve good fixings for items that need to be secured to the wall. Remember, the timber walls will be covered over internally and externally.

Aluminium gutters and downpipes were specified to further enhance environmental credentials in preference to the usual plastic. Aluminium is more expensive but, according to research, it is one of the best recycling materials. It can be recycled directly back into itself – over and over again. The use of aluminium also avoids the 'cracking' sound characterised by plastic alternatives when warmed by the sun.

Limestone chippings were laid around the border of the new extension and retained by recycled railway sleepers. These were fixed in place with steel hoops and painted with anti-corrosive red oxide paint; the hoops were made up by a local steel manufacturer.

The extension did not require Planning Permission. This is because it was less than the specified limit, as defined by the local authority for an end of terrace building, defined at 50 cubic metres. As described with previous projects, I carried out my usual array of tasks to get involved and reduce costs. An excellent way to ensure a builder makes regular progress, amongst other things, is to have a JCT Minor Works contract. I chose not to use one on this project because builders tend to slightly increase their quotations to compensate for the

obligations that the contract places upon them. But I would generally use this contract on this kind of project; it's easy to fill in and sets out the terms of the agreement.

How did it work out?

I was disappointed with my builder's progress on this project. I used to joke with him that there were times when I had to think twice to remember his name! And slow progress did have consequences. For an extended period, the sheeting that protected the roof was undone by a sudden downpour of rain. This caused very slight staining to the ceiling. I negotiated a saving, but that did not make me feel any better. The builder was recommended to me by the local authority. This slow progress was frustrating and made the build an uncomfortable experience for me. I just wanted to get the project done.

But despite the builder's slow progress, the standard of work was excellent. The new space provided a great place to work, direct access to the garden was a bonus, and the shower room was tightly planned but worked well. You may want to collect your own thoughts regarding the merits of the design.

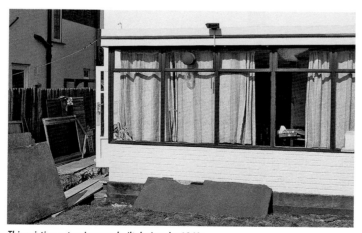

This existing extension was built during the 1960s.

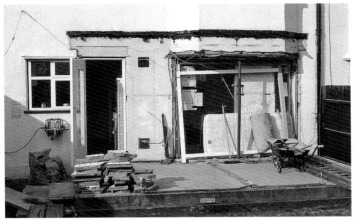

The existing extension has been demolished, the existing concrete floor slab will be reused with insulation added.

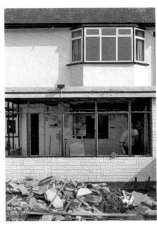

The new extension will extend across the width of the house.

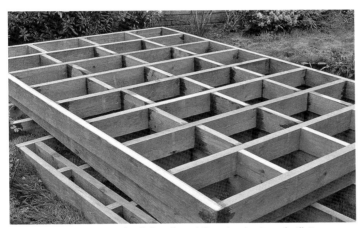

Purpose-built, timber treated walls have been delivered to the site and will sit on the new concrete foundation.

A new foundation has been dug beside the existing building and is 400 x 900mm deep.

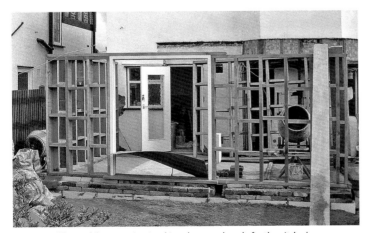

The general form of the extension is taking shape and ready for the pitched roof.

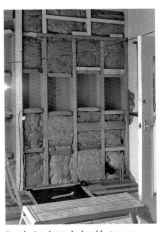

Insulation batts lodged between timber framing.

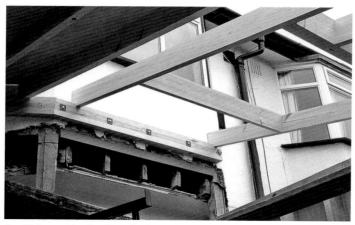

Rawl Bolts provide a firm fixing for the wall bearer that supports rafters.

Wall construction consists of timber structure and plasterboard, insulation, waterproof membrane, expanded metal ready for render and painted finish.

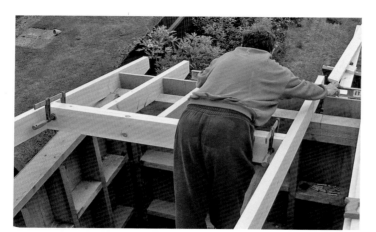

The location of the large rooflight has been established.

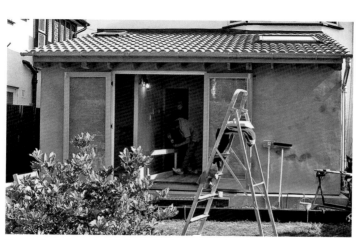

Progress has been made with the double doors, tiles and rooflights.

Aluminium rainwater goods discharge into an existing gully.

Detail of gutter arrangement.

The new extension is now complete; a railway sleeper is also used for the external step.

The small shower room is blessed with natural light.

Planting punctuates a bed of limestone chipping.

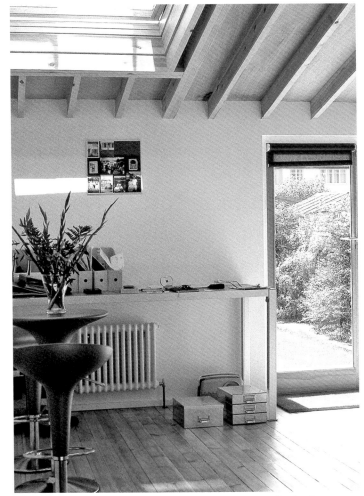

The ceiling rafters and plywood decking is exposed - the doors are fitted with maroon roller blinds.

79

To begin with, there didn't seem to be many options but it soon became clear that the project had great potential for a fascinating blend of interior and architectural design.

Lounge, Dining and Kitchen Design
CASE STUDY 10

Why do this project?

I left Cambridge and bought an apartment in London. Before moving in, I started thinking about reorganising the lounge, dining and kitchen into one space. The existing kitchen would be converted into a bedroom.

What is it about?

The simple card model is based on survey drawings and describes the existing space for this new project with its flat ceiling removed (you can see the flat ceiling line on the model). This has many advantages. It enhances the quality of the space,

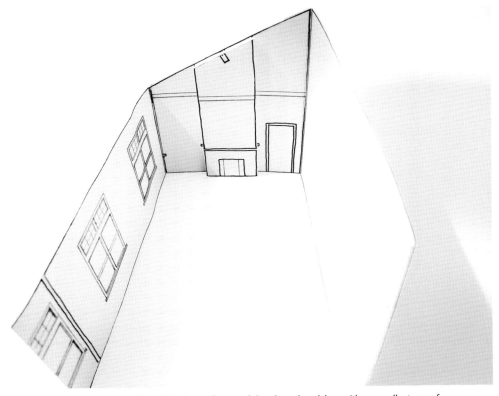

Model showing the space with the existing flat and sloping roof removed. Simple card models provide an excellent way of understanding the 3D characteristics of a space.

increases the volume and provides an easy way of introducing some glazing into the sloping roof. In particular, it would be good to get natural light to the floor space furthest from the windows. The space is approximately 7 x 5m and has two large windows, a fireplace and a cupboard.

You can see on the plan, Option 1, evidence of my first attempt to produce a design. I have established an axis – a theoretical line that organises the space. This line runs parallel with the window and back wall and coincides with the centreline of the fireplace. You can see the position of the dining table and sofa on my plan, which has been generated by my effort to organise the space. There is a storage cupboard opposite the windows, and the kitchen is positioned beside the entrance door. The dotted line on the drawing marks the position of new glazing in the roof, which will be fixed in place after the flat ceiling has been removed.

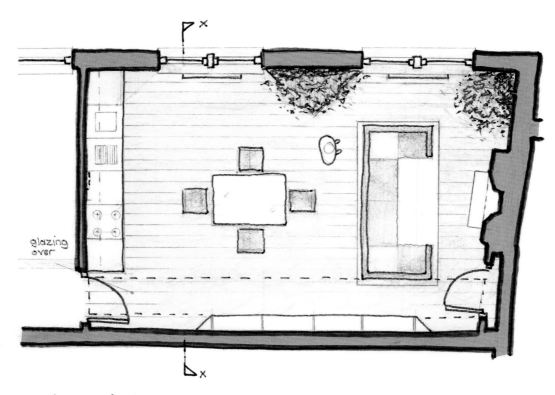

glazing over

Design Option 1 - single level arrangement Plan ₤

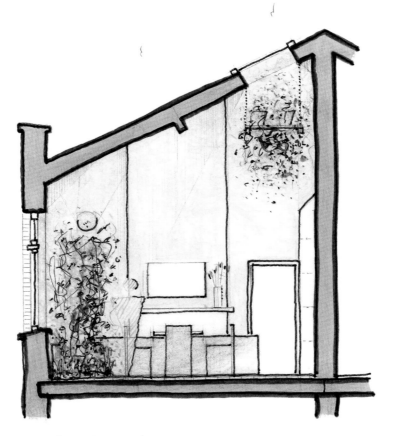

Section XX

You can see the glazing on Section XX. The section also gives details of planting at a high level which is watered from a rainwater storage tank. The drawing shows furniture, a TV, low level planting and a circular wall light (it's not difficult to see why drawings play a crucial part in design). I shall leave you to reflect on this proposal. I feel it is ok as a start; at least it demonstrates that it's possible to get the accommodation into the space. But I want to explore alternative arrangements. So I have listed five (not to scale) diagrams that I have named for reference purposes. In each case, the £ sign on the plan gives an indication of relative cost.

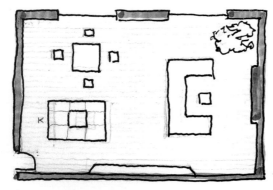

'island' - ✗

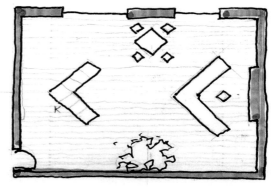

'chevron' - ✗

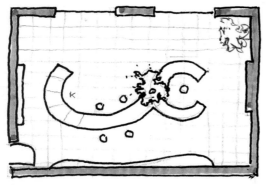

'Vortex' - ✗✗

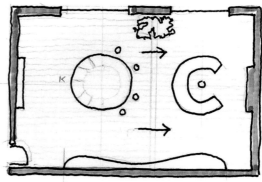

'circles' - ✗✗

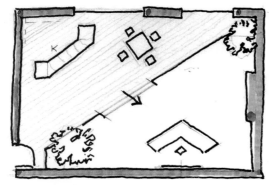

'oblique' - ✗✗

Alternative design ideas

'Island'

Shows the kitchen, dining and lounge.

'Chevron'

Here the elements are inclined at 45 degrees.

'Vortex'

Consists of a square floor tile with a swirl of purpose-built kitchen units, dining and sofa.

'Circles'

Offers a circular geometry with a change in level.

'Oblique'

Establishes a 45-degree line that divides the kitchen and dining from the lounge.

I have moved on from these simple diagrams and want to share my preferred design, Option 2, which uses extra space at a high level. The proposal is audacious. I felt I needed to work through this project and discover whether a greater level of experimentation would create a space full of panache and incisiveness.

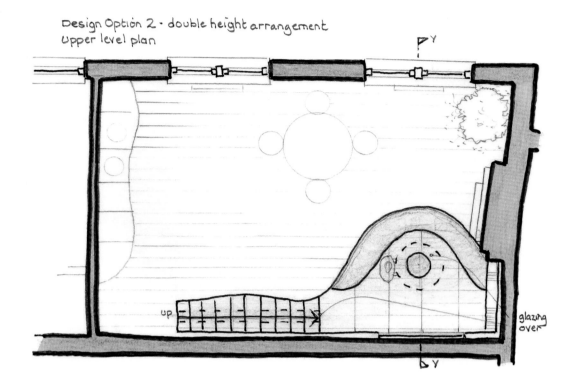

Design Option 2 - double height arrangement
upper level plan

up

glazing
over

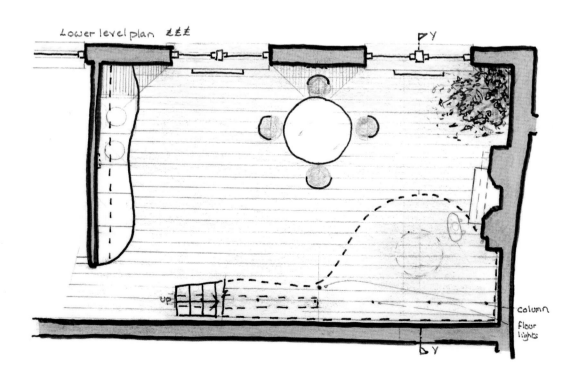

Lower level plan £££

up

column
floor
lights

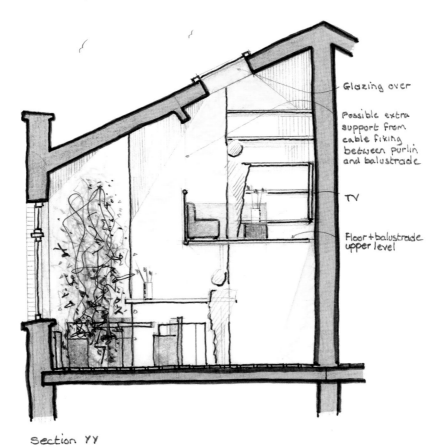

Glazing over

Possible extra
support from
cable fixing
between purlin
and balustrade

TV

Floor + balustrade
upper level

Section YY

You can see a play of curved shapes on the plan. The introduction of the curved line has a dynamic relationship with the existing rectangular space. In fact, this contrast between straight and curved lines has been a feature in the evolution of painting, and art in general, from the time humans began making marks on cave walls. Here the curved surfaces of the kitchen are mirrored in the handrail that leads to an upper level with a new lounge overlooking the kitchen and dining area below. (Does this remind you of anything? See: **The Big Picture** – Space.) Beneath the glass staircase and glass upper floor is a space that could be used as a study. Above and centred on the glass stair is a sliver of glazing in the roof, and this will allow light to pass through the upper level to the floor below. Section YY shows the upper level and includes furniture, storage shelves, planting and roof glazing.

These sketches need to be explored on a computer, and the design developed on to the next stage. I can visualise the space and look forward to seeing it in reality.

The design is very discreet – it speaks with a quiet voice.

Studio Design
CASE STUDY 11

Why do this project?

I was contacted by an art historian who wanted a studio. He was looking for at least 15 square metres and identified his existing roof space as the most appropriate place for it.

What is it about?

I recall there were two features to this project – the second was particularly memorable. First, my client demanded that minimum change should be done to his existing property. He was proud of his classic 1930s house – it was in excellent, original condition. I, too, could see the benefits of this approach. You would have noticed countless examples of plain ugly extensions – they fail to acknowledge the character and quality of the surrounding buildings. With my design, I confirmed my commitment to respond positively to the site's context and produce a discreet and appropriate design that embraced his user needs.

My client also said something of particular interest to me. I asked, 'what do you have in mind for your studio? What do you want?' He replied, 'what do you think I should have?' This was music to my ears – it is unusual to be offered this level of freedom. I like it. After all, I have completed many refurbishments in various forms and was aware of the options. So I was very keen to get started and began by surveying the existing building. My client confirmed his requirement for an open plan arrangement and was happy with my suggestion for a timber stair, floor and white walls. There are many good reasons for using white – it's a perfect way of ensuring the light is reflected around a space.

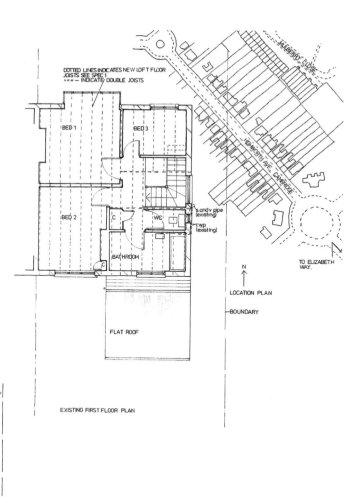

DOTTED LINES INDICATES NEW LOFT FLOOR
JOISTS SEE SPEC 1
--- = INDICATE DOUBLE JOISTS

BED 1

BED 3

BED 2

C

WC

BATHROOM

C

s and v pipe (existing)

r.w.p. (existing)

FLAT ROOF

EXISTING FIRST FLOOR PLAN

MULBERRY CLOSE

'ASHWORTH' AVE. CAMBRIDGE

TO ELIZABETH WAY.

N

LOCATION PLAN

BOUNDARY

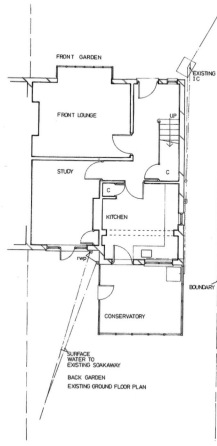

FRONT GARDEN

FRONT LOUNGE

UP

STUDY

C

C

KITCHEN

EXISTING I.C

r.w.p

BOUNDARY

CONSERVATORY

SURFACE
WATER TO
EXISTING SOAKAWAY

BACK GARDEN
EXISTING GROUND FLOOR PLAN

EXISTING GROUND AND FIRST FLOOR PLAN DEC '89

90

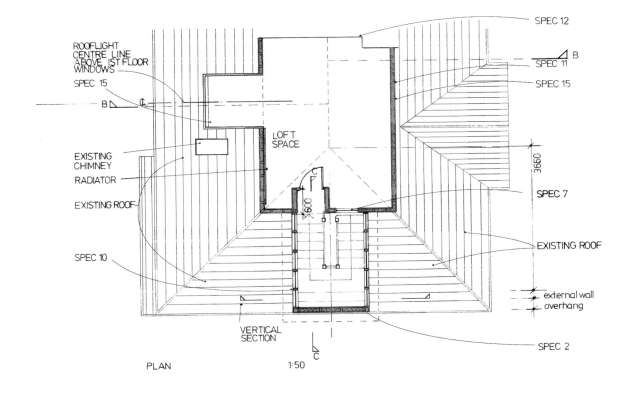

ROOFLIGHT
CENTRE LINE
ABOVE 1ST FLOOR
WINDOWS

SPEC 15

SPEC 12

SPEC 11

SPEC 15

LOFT SPACE

EXISTING CHIMNEY

RADIATOR

EXISTING ROOF

SPEC 7

EXISTING ROOF

SPEC 10

external wall
overhang

VERTICAL SECTION

SPEC 2

PLAN 1·50

I started producing a few design options. My plan drawing shows only one rooflight to the new studio. It is positioned over the centre line of the first floor bedroom window, offers splendid views of the rear garden and complies with my client's requirement for minimum change.

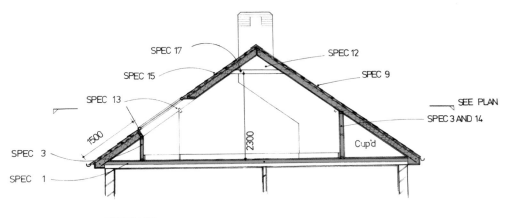

SPEC 17 SPEC 12

SPEC 15 SPEC 9

SPEC 13 SEE PLAN

SPEC 3 AND 14

1500 2300 Cup'd

SPEC 3

SPEC 1

SECTION BB

HIGHWORTH AVE, CAMBRIDGE. DEC '89

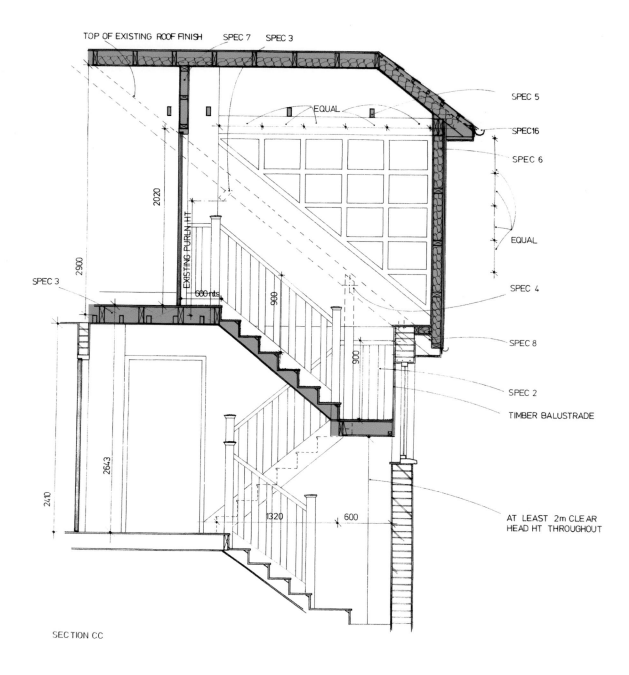

TOP OF EXISTING ROOF FINISH SPEC 7 SPEC 3

SPEC 5

SPEC16

SPEC 6

EQUAL

EQUAL

2020

2900

EXISTING PURLIN HT

600 nts

900

900

SPEC 3

SPEC 4

SPEC 8

SPEC 2

TIMBER BALUSTRADE

2643

2410

1320

600

AT LEAST 2m CLEAR
HEAD HT THROUGHOUT

SECTION CC

The existing hipped roof is precisely where the new stair will rise to provide access to the studio. The new stair also has a small hipped roof to echo the character of the existing building. You can see more detail on Section CC, Vertical Section and Detail AA. The proportion of the windows to the existing house are predominately vertical. To contrast this and endorse the look of notable 1930s architecture, I designed the stair glazing with a horizontal emphasis.

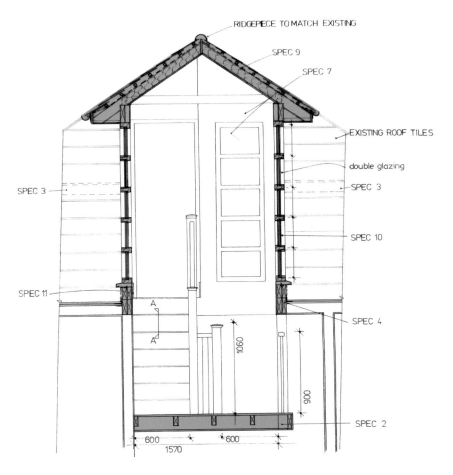

VERTICAL SECTION

DETAIL AA

Front Elevation

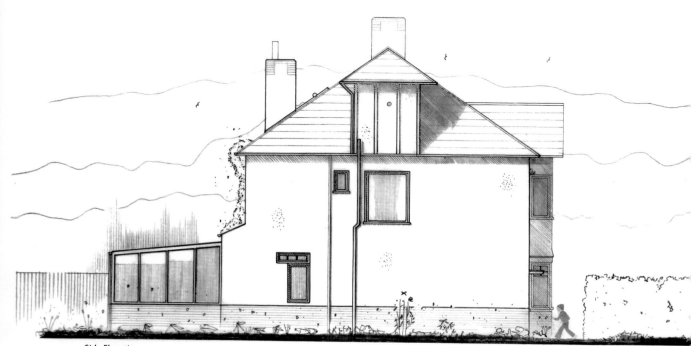

Side Elevation

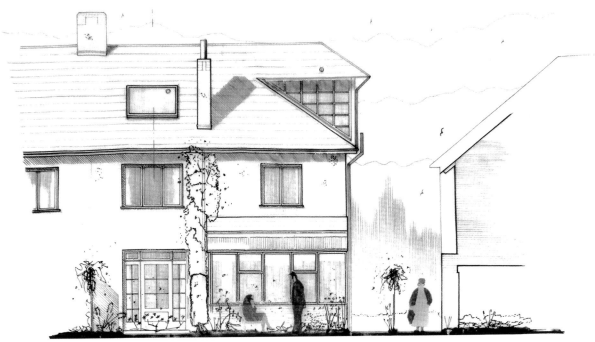

Rear Elevation

The studio has a fire-resistant, self-closing door with storage space along the front wall. Planning permission was not required because the roof profile was unchanged, but I did obtain Building Regulations approval. This coincided with a change in my client's method of financing this project. Sadly, these proposals were not built. But note – even when a Home Improvement doesn't go ahead, bear in mind that when the property is sold at a later date, it may be offered with local authority approvals. This could be very attractive to a prospective purchaser and command a higher sale price.

I have hardly ever known Home Improvement to be a bad idea; it's more a question of choosing the correct development and doing it well. My policy has generally been to buy the worst house in an attractive area. That way, any Home Improvement is virtually guaranteed not only to be a useful resource but also cost-effective when it comes to selling the property.

The flat is tiny but offers a fantastic opportunity for users to buy or rent their first property.

One Bedroom Flat
CASE STUDY 12

Why do this project?

Because of the demand for affordable accommodation, developers have turned their minds to create starter homes. These properties are for sale or rent, but to call them compact is an understatement. Following an approach by a client, I immediately started exploring planning arrangements to discover the implications of very tightly planned spaces on usability. So you can see, I have produced a few thoughts for a very compact kitchenette, shower / WC, bedroom and study.

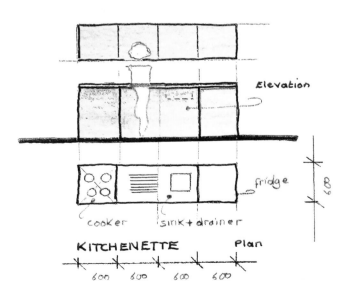

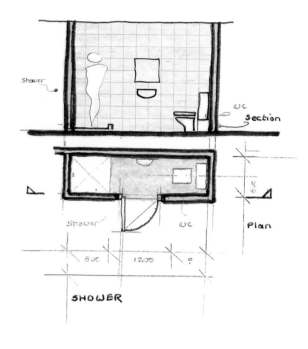

SHOWER

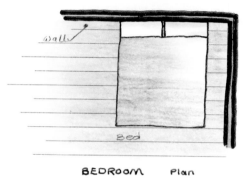

BEDROOM Plan

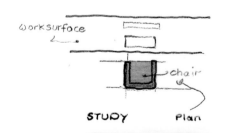

PLANT

STUDY Plan

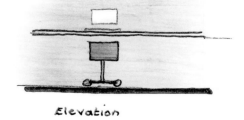

Elevation

Sketch Drawings

What is it about?

My client had purchased space within a grand building in west London. Approval had been given for change of use in favour of 12 flats, and I was commissioned to design one of them on the first floor. I am not exaggerating when I say the available floor space is very restricted. It is only 40 square metres – although this is positively palatial compared to the excessively modest 30 square metres for micro apartments that have become fashionable in urban areas in Europe, Japan, Hong Kong and North America. At least the dwelling I was working on would be self-contained, unlike the micro alternative that may have shared facilities.

In addition, my client required me to consider colour to help create a quality interior. The brief called for a kitchenette, lounge, shower room, WC, bedroom and dining area. I viewed this project as an exciting challenge and recalled staying in a tiny apartment in Tokyo, which was a fascinating experience. It confirmed that it is possible to successfully produce very tightly planned accommodation, although it requires users to think carefully about how to use the space. Clearly, the lack of space demands a tidy and somewhat minimalist lifestyle, which some would find unacceptable. These dwellings address the needs of singles or couples seeking to buy a home, perhaps for the first time. It is not a long term solution but does allow people to have a home of their own. And the gains are significant. Some of these sites, as in Tokyo, are located in attractive areas of the city.

So the accommodation footprint is minuscule, but at least the space I'm dealing with has got height. And it has three elegant sash windows that are south facing and provide quality light and great views into a leafy street. The important thing here is, think small – not easy for someone like me who is 2m tall!

As usual, I sketched out a few alternatives and gave them names in preparation for client discussions. (I sometimes produce these simple diagrams as I travel around London on public transport and then redraw them when I get back to my studio.)

'Angle'

Creates a diagonal with the sleeping accommodation separate from the living quarters.

'Central Spine'

Separates the accommodation into two spaces.

'Circles'

Produces a similar effect but with a different geometry.

'Wave'

Places the kitchenette and shower room in a narrow space with glazing over.

'Two Layer'

Two levels allowing the user to look down on the lower level.

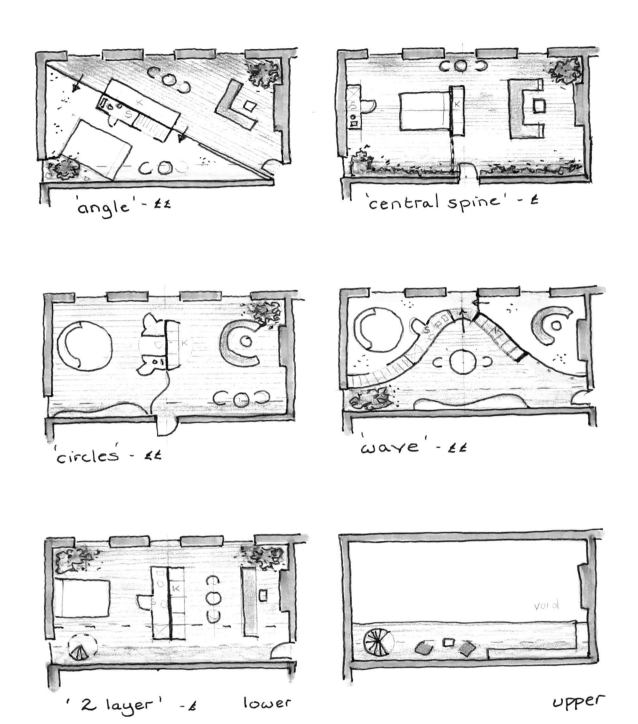

'angle' - ££

'central spine' - £

'circles' - ££

'wave' - ££

'2 layer' - £ lower

upper

Sketch Ideas

I produced some sketch drawings in the form of a plan and section CC.

Walls restrict movement and occupy space, so the arrangement is mainly open plan. To increase the sense of space, the central accommodation comprising storage, kitchenette and WC plus shower has a ceiling height of only 2.3m. It is, therefore, possible to look over this accommodation and into the space above the bedroom. It is a good idea to connect the proposed furniture arrangement and the geometry of the existing space. This is why, for example, the two chairs and table making up a mini dining area on the plan are positioned on the centreline of the existing window.

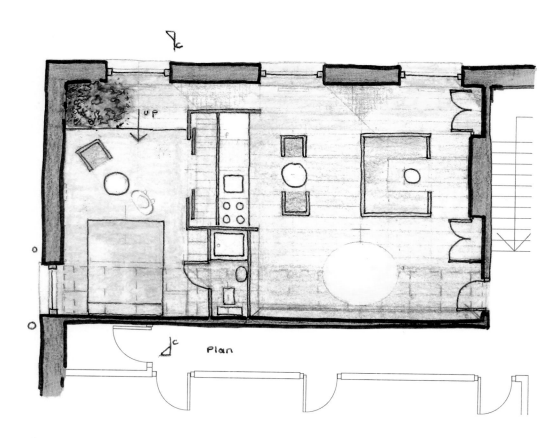

Plan

Room 12

Section CC

The bedroom is in a private space away from the main entrance. It has a raised floor to accommodate service pipes running from the kitchenette and shower and WC to the existing soil and vent pipe, which is fixed on the external face of the building. A small ramp will provide access for wheelchair users. And as you can see, I have not held back on my client's briefing to achieve richness and flamboyance by using colour.

At the point of this book going to print, this initiative is progressing well, and it will be interesting to see how my design measures up to other proposals within the building. I shall leave you to reflect not only on the detail of this design but, more widely, on this new way of procuring starter accommodation. I can only see this type of initiative growing in line with demand. In fact, there will be an increase in new builds, refurbishment and alterations due to the UK government's recent changes to the planning system.

A brief outline of key stages:

1 Survey

☐ Survey the existing arrangement and produce scaled drawings.

2 Brief

☐ The brief (user requirements) plays a crucial role. Consider what you want from your Home Improvement and its benefits. Think your proposals through and recognise that your requirements will change over time.

☐ Check how others have approached problems and sourced materials.

3 Constraints

☐ Check Local Authority Building Control and Planning Authorities / compliance with Tenancy or Lease Agreement.

☐ Consider Freeholder Consent / Party Wall Awards / Rights of Light and Access / Funding Requirements.

☐ Check Conservation Area and Listed Building status. Establish your budget.

4 Design

☐ Use **Skills Workshop** to map out your ideas and have another look at **The Big Picture** and **Case Studies 1 to 12**.

☐ Identify load-bearing and non-load-bearing walls and be prepared to consult with a structural engineer.

☐ Make good use of space – try alternative arrangements and be inventive. Get the proportion and character of the space right – you won't get a great interior without it.

☐ Try to get natural light into your home and consider general, task and accent lighting.

Even a small rooflight makes a difference to the quality of light inside your home.

☐ Consider using colour.

The bright ceiling provides a warm and exotic feel to the space. The colour was inspired by Stanley Kubrick films.

☐ Tiny details are essential; they all add up to make an attractive space. Think about the joints, faces and edges of materials.

☐ Check your Home Improvement works from a practical perspective.

5 Prepare your graphical and visual material

☐ Consider what information is required. Get quotations from, say, four builders and distinguish between the builder's work and other work carried out by you after your builder has left.

6 Statutory Requirements

☐ Obtain consents required before construction – may include Building Regulations and Planning Permission.

7 Appointment of Builder

☐ The appointment of a reliable and competent builder is *crucial*. Recommendations from friends, family and neighbours are an excellent way to start. Good builders are busy, so you may need to join the queue! Be prepared to negotiate with your builder to achieve savings.

☐ Confirm that you expect the work to be done to a professional standard and according to your issued information, usually consisting of drawings and specifications.

☐ A JCT Minor Works contract is a good way of securing the successful execution of a building project. So consider its use – it's beneficial in the event of a dispute.

☐ Take photographs to monitor progress.

8 Commencement of the Works

☐ Protect surfaces from damage and move furniture before your builder arrives.

☐ To manage your project – you need to manage yourself.

☐ Oversee your project from start to finish and anticipate problems. Have a look at materials as they are delivered to the site – it will send out a message to your builder that you are on the case.

☐ Don't underestimate the part played by your 'stickability' to get things done.

☐ Establish a good working relationship with your builder and agree, in advance, if you want to define the exact position of something, for example, your power sockets and light fittings.

☐ Be cautious about paying your builder 'up front', before the work starts on-site. If you are pressed on this, get the materials on-site and label them with your name and address before payment. Confirm to your builder, at the start, that upon completion of the works, funds are available for them to be paid. That will make them feel more relaxed. Don't pay them in full until you are happy with their work.

9 Completion

☐ At the end of a project, take time to evaluate its success and failures. And without being too critical of yourself, move on and apply this experience to your next project.

☐ Remember, the noise and inconvenience will fade from your memory after your builder has left – leaving you to enjoy your improved home.

Following the completion of your project, it would be easy to conclude that your only concern has been your new development. Maybe your bathroom has a new lease of life, your study benefits from more space or your new ground floor extension includes a superb dining area.

But there is more to it. My projects have involved me in carrying out the role of an architect, interior designer, part-time builder, project manager, labourer and tea-maker. While carrying out these tasks, I have made contact with various people, including builders, Building Control and Planning Officers, plumbers, electricians, floor and wall finishers and so on. And while the Home Improvement has been all-consuming, at least for a while, it is the personal interactions that have stayed with me. It's about improving your home, but it's also to do with working as a team, setting yourself a goal and achieving it. Central to the process is the interaction with people and personal development.

I have witnessed occasions when a conversation with clients has taken on a surreal character. Working on a refurbishment of a terraced house in Cambridge, I was talking with my clients Tom and Linda about the price difference between cement and Welsh slate tiles. Tom asked, 'what's the difference in price between the two?' I replied, 'the slates would cost about £500 more'. He said, 'how much is that in CDs?' I replied, 'I don't know what you mean. Do you mean Compact Discs?' He nodded. Nervously I asked, 'how much is a CD?' '£10'. 'Then,' I replied, 'it will cost you an extra 50 CDs.' On another occasion, we were discussing the cost of reclaimed York stone for their external space. He asked again, 'how much will it cost?' And I replied, '100 CDs!'

What was going on here? Couples do not always see eye to eye concerning their user requirements; they may not even agree on doing the project at all. In this case, Tom, a senior lecturer in music, had no interest in completing this project. His concern was expanding his treasured music library!

You will recall I mentioned the use of a JCT Minor Works contract. One clause within the contract states that work must be done to an appropriate standard – generally defined by the drawings and specification. In the event of work not being completed appropriately, within the terms of the contract, the Supervising Officer may condemn the work and request that it be done again. This clause must not be used inappropriately or unreasonably. It goes without saying that a site worker would not be pleased with this development. I have learnt something about condemning work. It's not a great idea when standing at arms' length from your builder if they are holding a shovel!

Years of developing properties have shaped my work practice. It would be great if one could identify a project, work on it and complete it. Then live with it for a couple of years – and then, a bit more. Finally, in the light of this learning experience, start again: but from the very beginning. Plainly this is not possible. There are other reasons why delaying the start of your improvement may be a good idea. Despite my approach of blitzing a property from day one, it's not always obvious how best to use your space. A pause might clarify your best way forward. Also, bear in mind that your property may be south facing, but you can't guarantee to get sunshine

throughout the year in urban areas. Sunlight may be blocked by surrounding buildings during the winter months, and that may make a difference to how you plan your home.

At the start of a Home Improvement, the scope of the work can be daunting, but remember, it's not long before you see progress.

Home Improvements will increase the value of your property and make it easier to sell. But you do need to have regard to how a prospective purchaser will appreciate your work. So you may want to have a word with an estate agent to check the merits of your proposals. But don't worry — from my experience, it has always worked out fine.

I recall leaving my front door open while talking to an estate agent who had called to discuss the sale of my first house. This occurred during the 1980s after I had spent a year refurbishing the property. A couple passed by, and I noticed they looked in. Before my agent had returned to his office, the

couple had already expressed an interest. They went on to buy it. Because my agent hadn't even advertised it, I should have requested that we renegotiate his fee! But whilst I've never had a problem selling, I have had a problem leaving my home that I had nurtured. One invests so much of oneself. Clearly, many couples, particularly with young children, want a home that is ready for occupation – where all building work is done. And they are prepared to pay for it.

Home improvement in the UK is failing in two areas; quality needs to be improved, and it remains an expensive proposition. Because there are two areas for concern, its current status reminds me of an old joke. Two friends are leaving a restaurant, and one turns to the other and says, 'Boy, the food at this place is really terrible.' The other one says, 'Yeah, I know; and such small portions!' Here, more participation from home owners with emerging skills and knowledge, all promoted in this book, will make a difference. And this will benefit everyone.

I leave you with one final thought concerning your future Home Improvements. When your builder doesn't turn up, despite their promise, and when you have made a point of staying at home to receive a delivery that isn't going to happen, and no one has had the gumption to tell you... Remember. Despite all of this, you will surmount the disappointments and reap the rewards of your efforts. And along the way – you'll probably enjoy it too!

Skills Workshop

Axonometric

A three-dimensional drawing that does not take into account perspective.

Circulation

Describes the way people move in, out and around a space.

Computer-Aided Design (CAD)

Programs that allow users to see their design on a screen and quickly amend, copy and visualise their proposals in 2D and 3D.

Detailed design

Drawings are drawn at a scale of 1:20, 1:10 and 1:5 to establish a greater level of refinement and can be used to provide accurate cost information.

Elevation

Representation of a three dimensional object in two dimensions.

Ergonomic Design

Graphical material that successfully takes into account the geometry and movement of people, function and their requirements.

Isometric

Method of graphical representation of a three dimensional object and used by technical illustrators, engineers and architects/interior designers. Differs from an axonometric in that the original plan has to be redrawn at an angle before the projection can be made.

Plan

Two-dimensional drawings or diagrams that show the arrangement from above.

Plan to scale

As before but drawn to scale.

Section

A 'sectional drawing' or 'section' represents a vertical slice as though it has been sliced in half or cut along an imaginary plane. It shows the nature of the interior, material and components.

Set square

A set square allows its user to draw straight lines. The one in the photo is adjustable and can be used to draw lines at an angle when used with a straight edge.

Sketch

A freehand drawing that is not intended to be a finished work.

Skirting boards

Usually made of wood, these cover the junction between the floor and wall whilst protecting the base of the wall from scuff marks.

Furniture and Fittings

Interior decoration

The decoration of a space that includes consideration of its surfaces, furniture, fittings and artworks.

CS1 Flower Box Design

Non-biodegradable

Matter that cannot be broken down by natural organisms and can remain on earth for many years to come without degradation.

CS2 Internal Door

Building Regulations

Statutory Instruments that provide guidance on the performance expected of materials and building practice. These are required for most building work.

FD30

A fire door that offers at least 30 minutes of protection against fire.

Victorian architecture

Victorian architecture is a series of styles that began in the mid-to-late 19th century and ended around 1900.

CS3 Storage Cupboard

Melamine

Melamine is a chemical compound and used in the Building Industry in various areas, including counters, tabletops and kitchen cupboards. (As indicated in the text, timber is a much better alternative.)

CS4 Lounge Refurbishment

Damp-proof course

A DPC is a material placed between courses of brickwork to stop rising damp affecting the walls. In the case of a suspended timber floor, the DPC helps protect timber against rot and mould.

Damp-proof membrane

A DPM is used underneath concrete floors to stop it from gaining moisture. To ensure complete protection from rising damp, the DPM should overlap the DPC.

Screed

Screed comprises one part cement to four parts of sharp sand and provides a smooth surface and level floor to lay a floor finish.

CS5 Garden Terrace

Pre-galvanised hanger

A pre-galvanised steel hanger provides a method of securing a timber joist to a masonry wall.

CS6 Walk-in Wardrobe

Schedule of Work

Lists individual elements of work required for a specific project. It would typically refer to supporting documents that include drawings and specification.

CS7 Bathroom Design

Waste pipe

A lightweight pipe used to discharge water from sinks, shower, washing machines or bath.

CS8 Loft Conversion

Box beam

Consists of sections of timber with plywood sheets on each side. Unlike a solid beam, a box beam is hollow on the inside.

Planning permission

Local authority permission is required for a development to go ahead. Approval may be needed in the case of new build, material alteration and change of use.

CS9 Single Storey Extension

Modernism

Modernism was a break from the past following the end of the First World War that nurtured a period of experimentation in the arts. In architecture, it manifested sleek, clean lines at the expense of decorative features.

Thermal mass

Relates to the mass of a building which enables it to provide resistance to temperature fluctuations.

CS10 Lounge, Dining and Kitchen Design

Axis

A real or imaginary line around which things are organised. They are often used in plans to establish an overarching idea, order, pattern and unifying element.

Sliver of glazing

A long, narrow band of glazing in the wall or roof that provides natural light and enhances the drama and quality of a space.

CS11 Studio Design

Brief

Details that define a client's requirements and aspirations which is best created following dialogue between building user and designer.

Hipped roof

A hipped roof is where all sides slope downwards. They offer less internal space but because their interior bracing offer good wind resistance.

Survey

The process whereby accurate measurements are taken, and plans and sections produced that describe the existing layout and characteristics of a property.

CS12 One Bedroom Flat

Soil and vent pipe

A vertical pipe that discharges soiled water from the toilet, urinal and bidet to the soil drain and onwards to the sewage works.

Action Plan

Home Improvement

The concept of Home Improvement embraces repairs and updates in the form of decorations and new finishes. More ambitious projects include structural alterations and external works. The benefits include energy conservation/efficiency, comfort, maintenance, increased space, improved facilities, safety and financial return.

Mahler's Heavenly Retreats
Encounters with the master's
'Composing Houses'